IMAGES
of America

HERKIMER COUNTY
VALLEY TOWNS

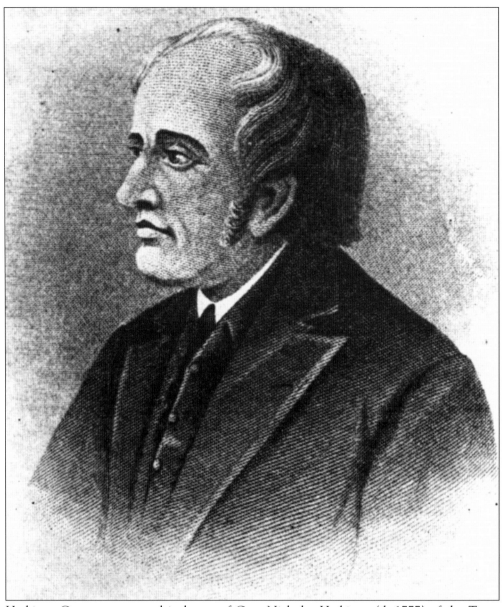

Herkimer County was named in honor of Gen. Nicholas Herkimer (d. 1777) of the Tryon County Militia. He was a hero at the Battle of Oriskany in 1777. His parents, Johan Jost and Catherine Herkimer, and grandparents were among the original Palatine settlers in 1725.

On the cover: The Fort Dayton Hose Company was organized in 1875 to take charge of Herkimer's newly purchased steam fire engine. This company set records for extinguishing fires and won prizes for drilling exercises. The band is seated on the steps of the First United Methodist Church, on Prospect Street.

IMAGES
of America

HERKIMER COUNTY
VALLEY TOWNS

Jane W. Dieffenbacher

ARCADIA
PUBLISHING

Published by Arcadia Publishing
Charleston SC, Chicago IL, Portsmouth NH, San Francisco CA

Printed in the United States of America

Library of Congress Catalog Card Number: 2001098960

For all general information contact Arcadia Publishing at:
Telephone 843-853-2070
Fax 843-853-0044
E-mail sales@arcadiapublishing.com
For customer service and orders:
Toll-Free 1-888-313-2665

Visit us on the Internet at www.arcadiapublishing.com

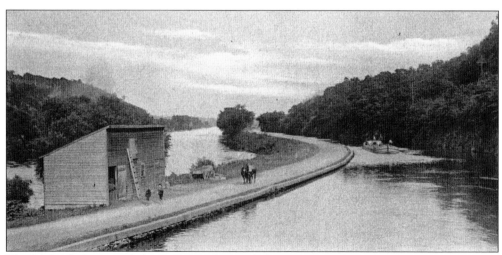

The Mohawk River and the Erie Canal provided a waterway through the eastern mountain ranges, opening the interior of the country for immigration and trade.

CONTENTS

Introduction 7

Acknowledgments 8

1. Palatine Heritage 9

2. Establishing Justice 21

3. From Canal to Thruway 27

4. Abundant Land and Labor 45

5. Hometowns 65

6. Providing for the Common Defense 87

7. The Pursuit of Happiness 95

8. Promoting the General Welfare 111

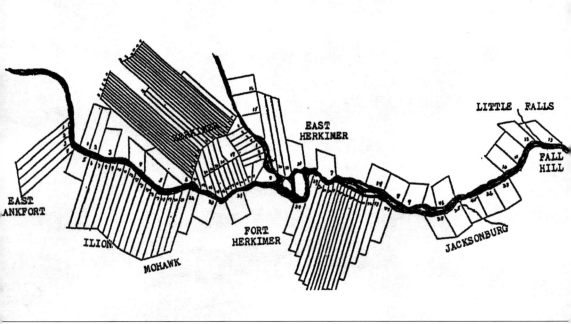

Gov. William Burnett signed the Burnetsfield Patent on April 30, 1725, giving 92 Palatines 100 acres apiece, north or south of the Mohawk River. The West Canada Creek is shown entering the river from the north. (Courtesy Jane Bellinger.)

INTRODUCTION

Herkimer County in central New York is composed of 19 towns and extends into the Adirondack Mountains on the north and the lands south of the Mohawk River. This book introduces the seven towns that border the Mohawk; they were the earliest settled and the most populated towns in the county. The natural waterway allowed easy penetration of this area by settlers and provided transportation of crops and manufactured goods to large markets to the east and south.

The Mohawk Indians, part of the Iroquois Confederation, enjoyed the valley area before the arrival of Europeans. A period of trade introduced the Native Americans to European technology and provided furs in return.

The German Palatines settled on the Burnetsfield Patent c. 1723. The patent lands were between Frankfort and Little Falls, north and south of the Mohawk River.

The French and Indian War was followed by a peaceful period during which the Palatines recovered from the war's destruction, only to be devastated once more by the Revolutionary War. At the war's end, New Englanders began to pour into the valley, eager to purchase land that was taken from the Tories. The English and German cultures worked together as local government was formed.

The town of Danube, south of the Mohawk River, is the site of Indian Castle Church. The upper Mohawk Indian Castle, home of the Mohawk chief King Hendrick, was located here. Gen. Nicholas Herkimer built his home near the river. Dairy farming continues to be the main industry. The town has no incorporated villages but does have a few hamlets, Newville being the largest.

Danube's neighbor to the north is the town of Manheim. Mainly agricultural, Manheim includes the western half of the village of Dolgeville and the power station at Ingham Mills. Its eastern boundary is the East Canada Creek.

The town of Little Falls extends both north and south of the Mohawk River. The city of Little Falls sits astride the Mohawk. The county's only city, Little Falls, grew around the rocky hazards of the river. Travelers would have to carry their boats to pass by these dangerous waters. Later, the waterpower available here led to industrial development.

German Flatts, south of the river, is the site of the 1756 Fort Herkimer and the villages of Mohawk and Ilion. As with the other valley towns, its population is concentrated by the river and canal.

The town of Herkimer, north of German Flatts, was the site of the 1776 Fort Dayton. The Palatine settlement developed into the village of Herkimer, which became the county seat. A curious circumstance caused the names of Herkimer and German Flatts to be reversed.

In 1788, the surveyor general asked where the towns were located. He was answered by Dr. William Petry, whose viewpoint was below the mouth of the Mohawk, looking up the river. The surveyor general thought his viewpoint was the way the river flowed. Hence, the names were reversed on the map, enacted into law, and have so remained for more than 200 years.

The town of Schuyler, on the river's northern bank, has developed along Route 5, the main road connecting Little Falls and Herkimer to Utica. East Schuyler and West Schuyler are extended hamlets along this highway, where farm stands sell local produce in season.

The town of Frankfort borders Schuyler south of the Mohawk. The village of Frankfort is the only incorporated municipality. The Herkimer County Fairgrounds are here, and Route 5S provides quick access to Utica.

The valley towns have much in common: rural lands of great beauty and agricultural importance, industrial development near waterpower and transportation routes, and a central position between the Adirondacks to the north and the Catskills to the south. The area is gradually changing as industry follows a general movement to the south and west. Numerous family farms have been abandoned or consolidated into larger operations. Many valley people pursue their livelihoods in Utica and neighboring population centers. Nevertheless, people continue to purchase land and build homes in this area. The beauty of the valley and surrounding hills remains an outstanding feature and, combined with its rich historical heritage, provides an attraction for visitors in a developing tourism industry.

The source of the material in this book is the Herkimer County Historical Society. The society's photograph collection and extensive library of local history are unmatched in this area. Photographs were selected for this book by availability and represent the industry and culture of the valley towns. Numerous churches add their faith and beauty to the valley towns, too many to represent here. They can be viewed in *Prayer and Praise*, by Emily Denton. This book is not inclusive but is intended to represent an overview and the main characteristics of a valley that continues to be a fine place to call home.

—Jane W. Dieffenbacher

ACKNOWLEDGMENTS

All photographs, unless otherwise noted, are from the collection of the Herkimer County Historical Society, received with gratitude from donors over many years. The author is grateful for the use of the historical society's collection and library. The following people have helped the author in many ways: Jane Bellinger, Florene Burkdorf, Betty Currier (Town of Schuyler historian), George Dieffenbacher, Lillian Gaherty (Village of Mohawk historian), Phil Lord of the New York State Museum, Susan Perkins of the Herkimer County Historical Society, and Patrick Wilder. In addition, workers and volunteers at the historical society offered valuable information. The author is also in debt to the Dolgeville-Manheim Historical Society.

One

PALATINE HERITAGE

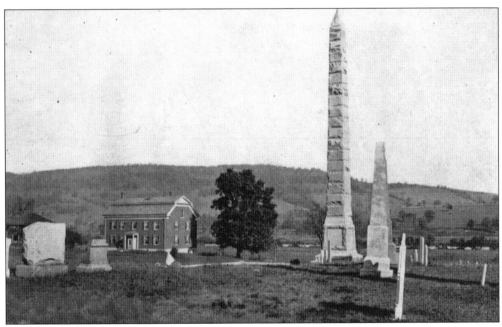

This early photograph shows the Nicholas Herkimer Home and Monument. The efforts of Delight E. Ransom Keller resulted in a state appropriation for the purchase and preservation of the home. In 1914, Delight Keller, a national and state chairman of the Daughters of the American Revolution, conceived the idea of locating and marking Gen. Nicholas Herkimer's march to Oriskany.

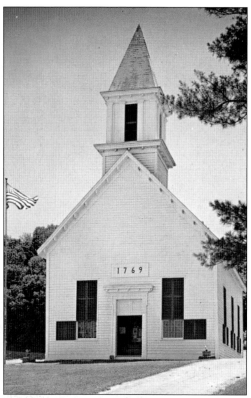

The Indian Castle Church, in the town of Danube, was constructed in 1769 by Sir William Johnson, British superintendent of Indian affairs, on land donated by Joseph Brant. It was dedicated as a Native American mission in 1770 under the auspices of the Church of England. A few years later, Joseph Brant and the Mohawks fought on the British side at the Battle of Oriskany. (Courtesy Tom Gregorka.)

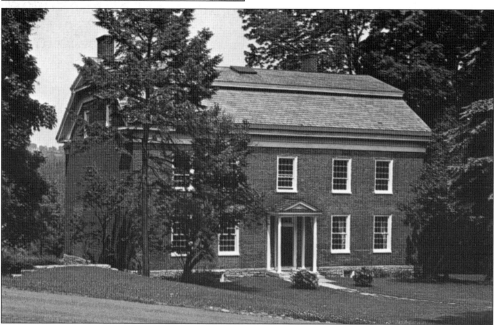

Also in the town of Danube is Gen. Nicholas Herkimer's home, built in 1764 as an English-American Georgian brick home. Nicholas Herkimer benefitted from the trade and lands held by his father. His wealth enabled him to construct this impressive mansion. (Courtesy Tom Gregorka.)

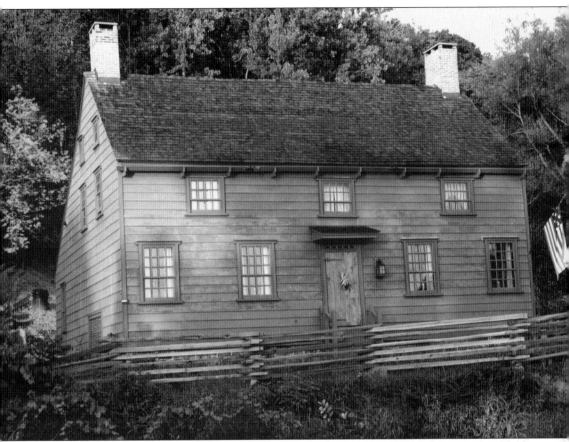

The Wohleben-Wilder House (located on Route 5 on a site overlooking the Mohawk Valley) is a rare 18th-century Palatine-German house. It was constructed between 1780 and 1785 on Great Lot No. 2, which was created in 1723 and owned by Anne Feltelandt. One of Feltelandt's daughters married Nicholas Wohleben (English spelling: Wollever) but died two years later. Nicholas Wollever was granted Great Lot No. 3 on the south side of the Mohawk River but donated this land for the building of Fort Herkimer Church. His grandson Nicholas Wollever (1769–1861) inhabited this house until his death. The property remained in the possession of the Wollever family until nearly World War I. The current owners have restored the house to its 1780s appearance. (Courtesy Patrick Wilder.)

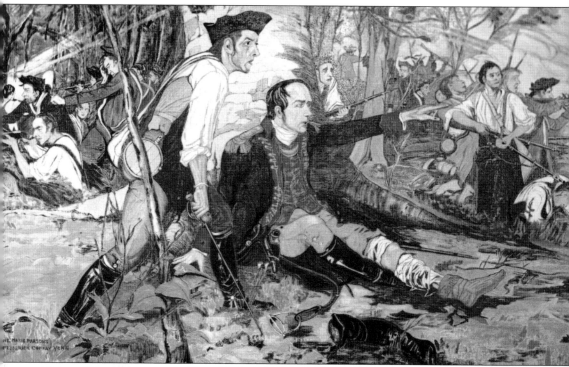

This well-known painting of Gen. Nicholas Herkimer at the Battle of Oriskany, by Frederick C. Yohn, is displayed in the Utica Public Library. On August 6, 1777, General Herkimer—leading 760 Tryon County militiamen and 60 Oneida Indian warriors to the relief of Fort Stanwix, which was under siege by British and Native American forces—was ambushed. During the early part of the bloody conflict, his leg was shattered. His men placed him on his saddle against a tree, where he continued to issue orders for six hours. After the battle, the general was carried home, where his leg was amputated about 10 days later. The unskillfully performed surgery resulted in the general's death. He never learned that the effort of his gallant forces led directly to the alliance with France, which enabled the Americans to gain independence.

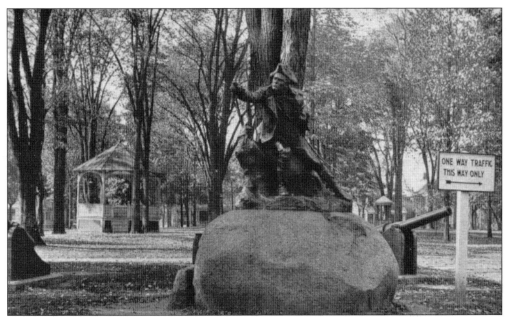

This statue of Gen. Nicholas Herkimer, by Burr C. Miller, graces Myers Park in Herkimer. A gift of the Honorable Warner Miller (senator), the statue was unveiled on August 6, 1907. Placed on a boulder from near Alder Creek by the Gen. Nicholas Herkimer Chapter of the Daughters of the American Revolution in memory of those who have died for our country, the statue stands guard over the site of an early Herkimer cemetery, now Myers Park.

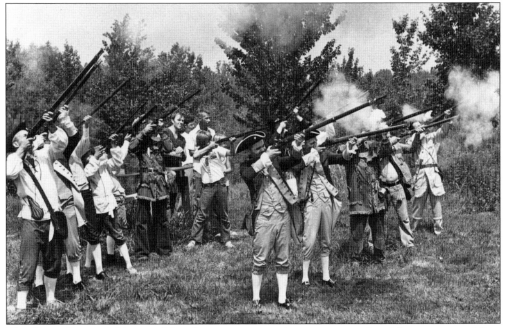

The Tryon County Militia and Loyalist groups meet almost every weekend from spring to fall at different locations and celebrations in the Mohawk Valley. They add color and authenticity as they bring America's Revolutionary heritage alive. Their research is a fine source of information on the patriots who earned our independence.

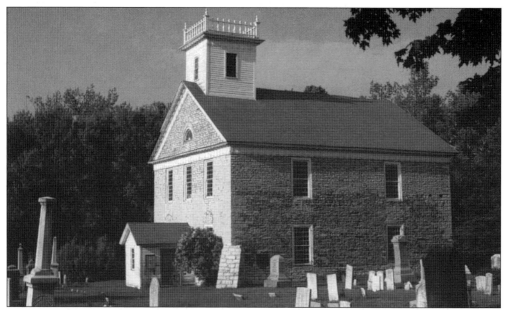

In c. 1752, Palatines began to build what became known as the Fort Herkimer Church near the fortified homestead of Johan Jost Herkimer. In 1767, it was a single-story structure. A second story was added in 1812. Located in the town of German Flatts, the church is being maintained and is open for Thanksgiving services annually.

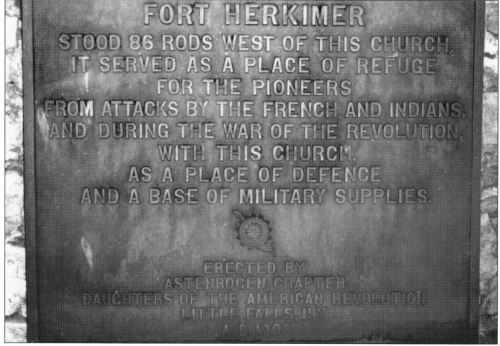

By November 1756, British forces had completed Fort Herkimer. In November 1757, French and Native American forces raided the settlement north of the Mohawk, causing great destruction. Those who were able sought refuge in the fort, which was garrisoned by British regulars. The fort was also used during the Revolution.

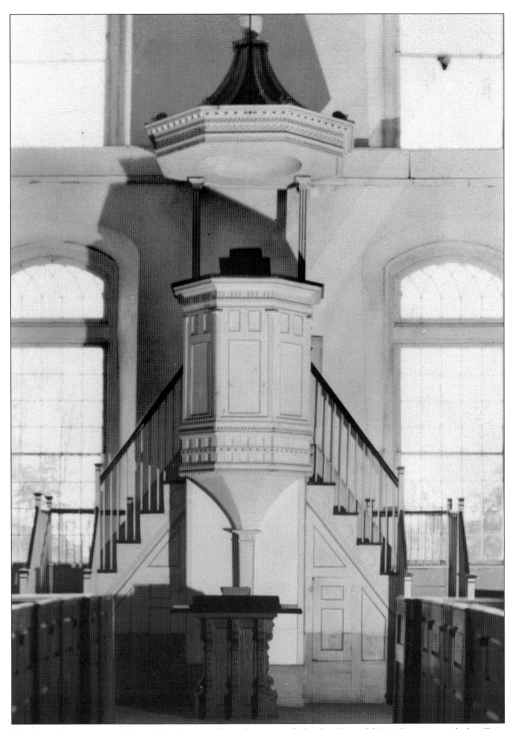

The lovely interior of Fort Herkimer Church is cared for by Donald M. Fenner and the Fort Herkimer Board of Commissioners. The Palatines established this church as a Dutch Reformed church and called as minister a Mr. Rosecrants. He was succeeded by his brother, Rev. Abraham Rosecrants. They are said to have been buried under the pulpit.

The Herkimer Reformed Church's bicentennial was celebrated in 1923, drawing a crowd of participants. In 1723, an octagon log church was built by the Palatine settlers. In the 1757 raid of French and Native Americans, the church was burned. A second church was built,

which burned c. 1801. A third church was started in 1804 and completed in 1809. In 1834, the prisoners in the jail across the street set fire to the jail and the church was destroyed as well. By 1835, the present Reformed church was built of brick.

The Reformed church stands amid the resting places of Palatines from Herkimer's earliest days. The sanctuary was redecorated in 1912 by the Louis Comfort Tiffany Company of New York. Many renovations have recently been made to meet the needs of the congregation. This Masonic Temple was completed in 1919 by Herkimer Lodge No. 423, Free and Accepted Masons, chartered in 1857.

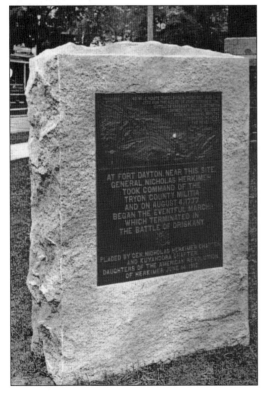

This monument was placed in front of the courthouse by the Daughters of the American Revolution in 1912 to commemorate Fort Dayton. The fort was built in 1776 by Col. Elias Dayton and the 3rd New Jersey Regiment of the Continental Army to protect and defend the citizens of German Flatts. The fort was thought to have occupied the ground now bordered by North Main, German, Washington, and Court Streets. Gen. Nicholas Herkimer marched from here to the Battle of Oriskany in 1777.

Francis Elias Spinner was born in 1802 while his father was beginning his 47 years of service to the Reformed Church of Herkimer and German Flatts. Francis E. Spinner served as the sheriff of Herkimer County and became involved in the development of railroads, banks, and various businesses. He was appointed deputy naval officer and served in the Port of New York. Election to Congress followed in 1854. In 1861, Spinner became the 10th treasurer of the United States. He served under three presidents (beginning with Abraham Lincoln) and was credited with postage currency and increased employment of women in government positions. His home, a Classical Revival house on Main Street in Mohawk, was built in 1841. In 1842, he installed a concrete sewer pipe from his home to the Erie Canal, the first such installation in the United States.

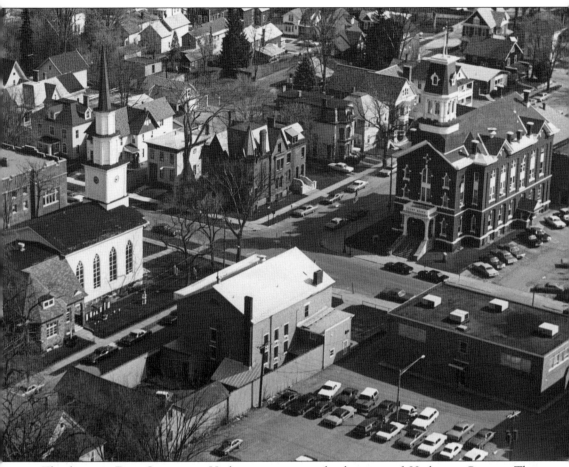

The historic Four Corners in Herkimer represent the heritage of Herkimer County. The courthouse and jail facing each other across Main Street stand for many years of justice. The Reformed Church represents the beginning of religion in the community, while the Herkimer County Historical Society on the opposite corner holds the historic artifacts and the story of Herkimer County's development.

Two

ESTABLISHING JUSTICE

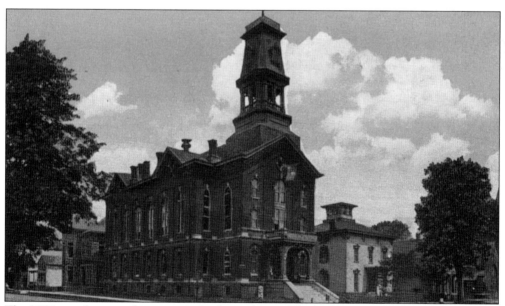

The 1873 courthouse is the county's third courthouse. The building to the right was the county office building, purchased in 1917. The first courthouse, a two-story frame building with the jail on the ground floor, was destroyed by fire in 1834. The second courthouse, a two-story brick building with six columns, was erected in 1834 and was taken down in 1873 when it proved too small. In 1998, the courts were moved to the new Herkimer County Office and Courts Facility, on Washington Street.

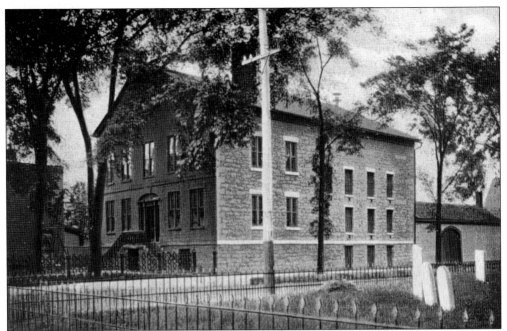

Located on the corner of Main and Church Streets, this jail was erected in 1834 to replace the jail burned in the old court building. The stone was quarried in the Little Falls vicinity. The twin stone stairs add interest to the facade. The sheriff and his wife lived in the jail building and provided meals for the prisoners. State requirements led to the building of a new jail on Court and Washington Streets in 1977.

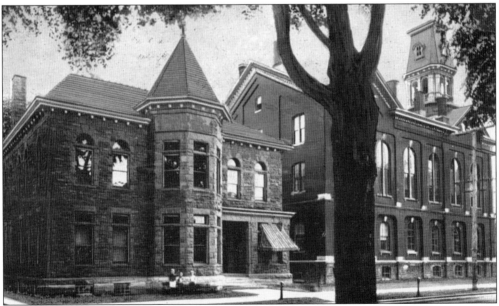

A two-story building of red stone was erected on Court Street in 1895. The earliest county clerk's building was built of wood and destroyed by fire in 1804, a disastrous loss of records. A new building was erected in 1804 and replaced in 1847. In 1895, it was replaced by the present structure, which serves as the office of the county treasurer.

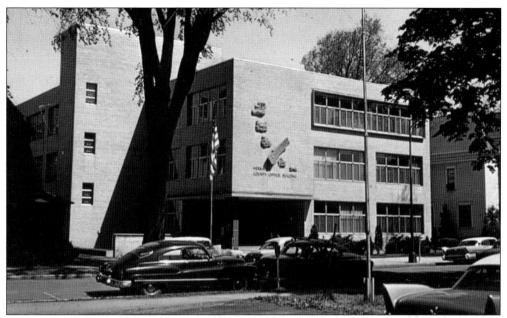

Dedicated in 1954, this building on Mary Street served the county's need for office space for many years, until the number of agencies and the administrative needs of a modern county necessitated the new Herkimer County Office and Courts Facility, on Washington Street. The county clerk and several other offices remain in the Mary Street facility.

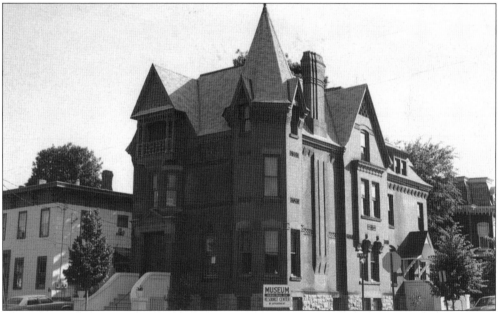

The museum of the Herkimer County Historical Society is housed at 400 North Main Street in the Suiter Building, the bequest of Dr. A. Walter Suiter in 1925. Suiter contracted with architect Adolphus Simmons to design this imposing house of more than 20 rooms in 1883. He used three rooms in the rear for his medical practice and never lived in the house. The Eckler Building, next door, was acquired by the historical society and now houses the resource center, gift shop, and offices.

Grace Brown of South Otselic, Chenango County, was the victim of what was called the murder of the century. Herkimer residents were in the eye of the national media when Grace's supposed murderer was brought to the Herkimer Jail on July 14, 1906, to stand trial. Grace Brown was pregnant and wanted her lover, Chester Gillette, to marry her. Instead, he lured her with false promises on a trip to Big Moose Lake in the Adirondacks, where they rented a rowboat. Grace was found in the lake the next day.

Chester Gillette met Grace Brown in a Cortland skirt factory. On those evenings he was not with Grace, he socialized with the elite of Cortland. Grace stood in the way of his social climbing. According to the prosecution, he hit her with a tennis racket and threw her body into the lake. Gillette claimed she committed suicide by jumping out of the boat.

Herkimer County district attorney George W. Ward, a lawyer residing in Dolgeville, was elected in 1903. Ward and undersheriff Austin B. Klock pursued Gillette and delivered him to the jail to await trial. The sensational nature of the crime brought dozens of reporters to Herkimer. The notoriety attracted crowds, who watched Gillette being taken from the jail to the courthouse. Theodore Dreiser's novel *An American Tragedy* was based on the Gillette case. A later film, *A Place in the Sun*, contributed to its place in the public eye.

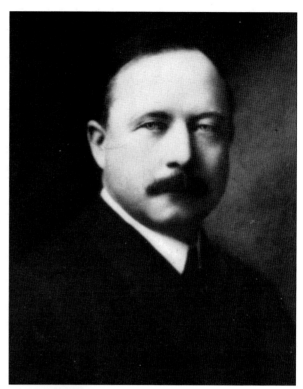

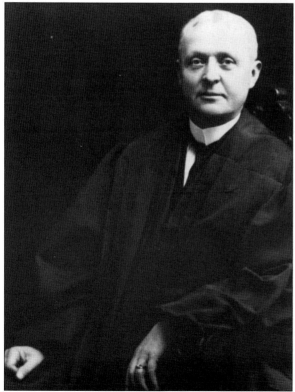

The Honorable Irving Devendorf, a descendant of Palatine settlers, was a justice of the Herkimer County Supreme Court. The Gillette trial was his first murder trial. The jury found Gillette guilty of murder, and Devendorf sentenced him to death at Auburn Prison. The Court of Appeals upheld the conviction, and Gillette died in the electric chair on March 30, 1908.

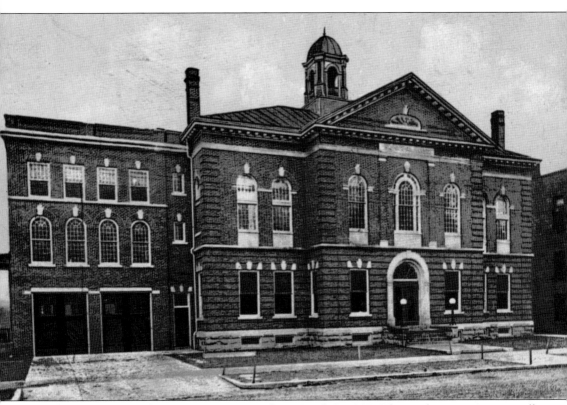

The village of Herkimer was incorporated on April 6, 1807. The settlement was originally known as Stone Ridge due to an outcropping of rock. The original five trustees were empowered to raise not more than $200 per year to purchase fire equipment and ensure a supply of water for firefighting. This c. 1902 building on Green Street served as the municipal hall and fire department. It was demolished in 1991, by which time the fire department was operating from new quarters on Washington Street.

Three

FROM CANAL TO THRUWAY

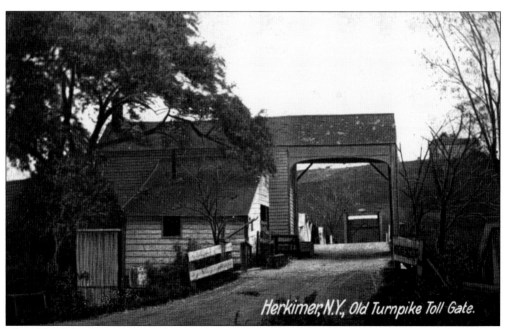

Herkimer, N.Y., Old Turnpike Toll Gate.

The old toll bridge at East Herkimer in the early 1900s was a familiar sight to travelers between Herkimer and Little Falls. Those using the bridge to cross West Canada Creek were charged fees from 2¢ and up, depending on the type of vehicle and number of horses or oxen. It was operated by Mrs. Patrick McAuliffe. The house and bridge were razed in the early 1900s.

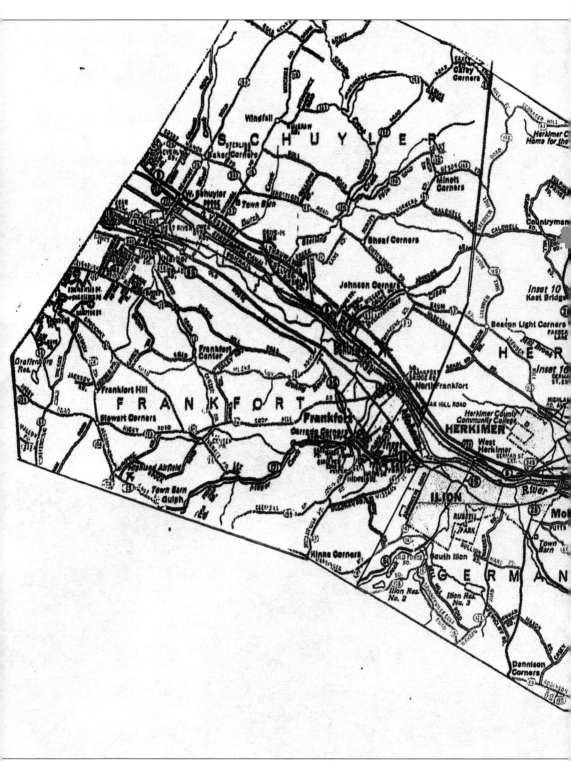

A glance at the map of Herkimer County's valley towns shows that the Mohawk River serves as a geographic and political boundary for several towns. The villages with the greatest population

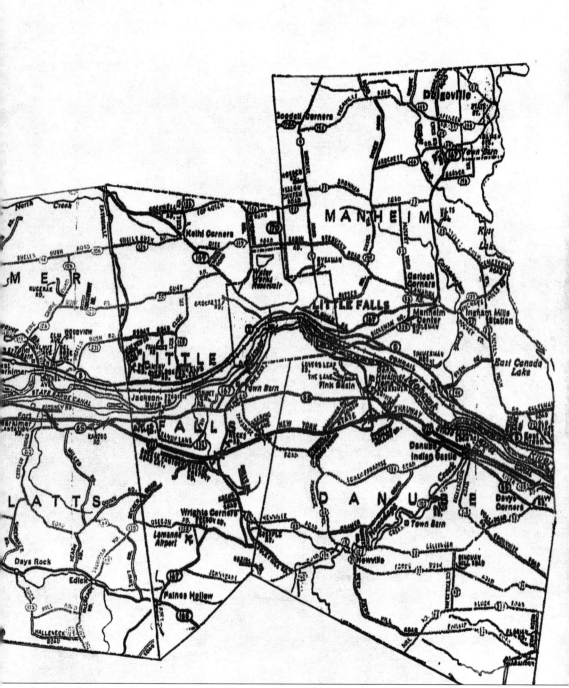

developed in the valley where conditions were favorable for industry. Many ethnic groups came to work in the factories, adding to the diversity of culture in the valley.

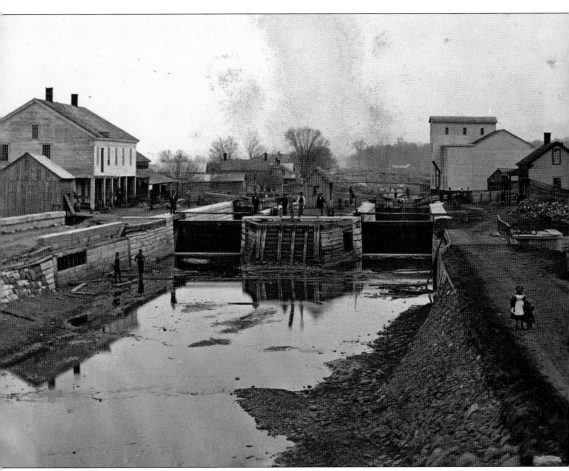

The two small girls on the right are walking by the Erie Canal lock in Frankfort. The picture was taken from Cemetery Street, looking east. The canal is temporarily drained for repairs and will be filled by Moyer Creek when repairs are completed. The sign on the building at the left reads, "SAW DUST FOR SALE." When the Erie Canal opened in 1825, stores were built along the way to provide for the needs of packet boat passengers, and businesses developed where it was easy to receive raw materials and to ship finished products.

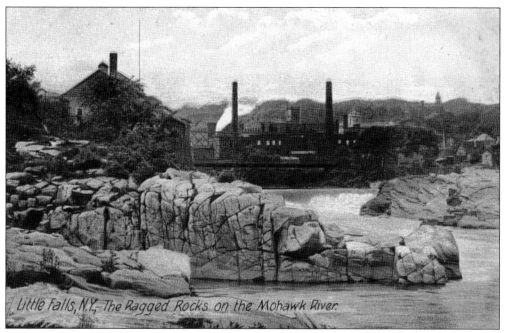

Little Falls, N.Y., The Ragged Rocks on the Mohawk River.

The rocks and 40-foot drop in the Mohawk River at Little Falls were bypassed by locks constructed in 1796 by the Western Inland Lock Navigation Company. However, it was not until the Erie Canal was completed in 1825 that New York State had a reliable, inexpensive way of water transportation.

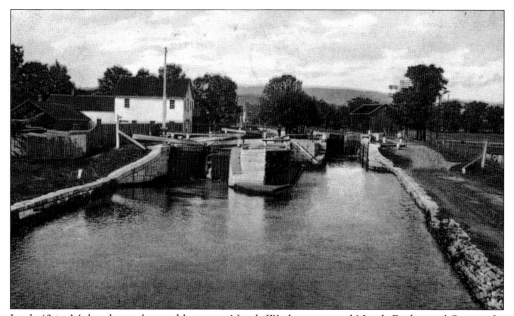

Lock 42 in Mohawk was located between North Washington and North Richmond Streets. In this view, the towpath is visible on the right. The barn on the right remains standing. (Courtesy Lillian Gaherty.)

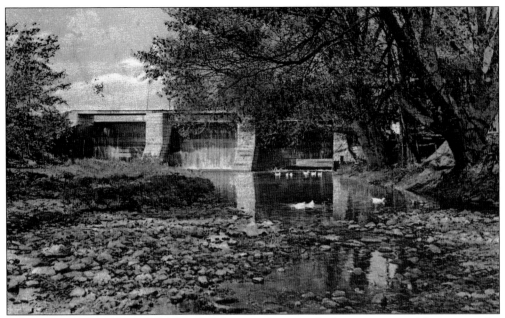

Fulmer Creek flows through Mohawk. This aqueduct was built to carry canal boats over the creek. The boats were lifted by means of Lock 43 (behind the trees to the right). (Courtesy Lillian Gaherty.)

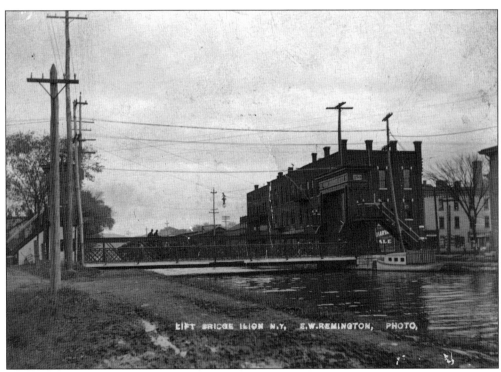

There were many kinds of bridges spanning the Erie Canal and the Mohawk River. This was a lift bridge over the canal in Ilion near one of the Remington plants.

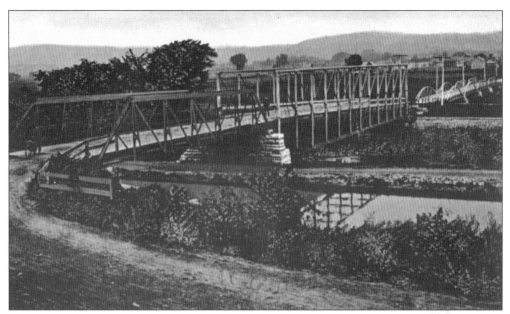

These bridges spanned the canal and river, going from today's Route 5S to South Washington Street in Herkimer.

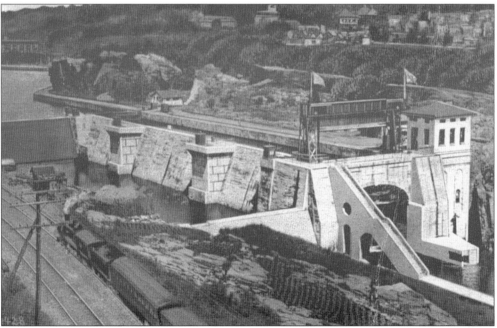

In 1903, voters approved the rebuilding of the Erie Canal. Using parts of the Mohawk and other rivers, the Erie, Champlain, Oswego, and Cayuga and Seneca Canals were incorporated into the New York State Barge Canal System, completed in 1918. The 40.5-foot lift lock at Little Falls is higher than any Panama Canal lock.

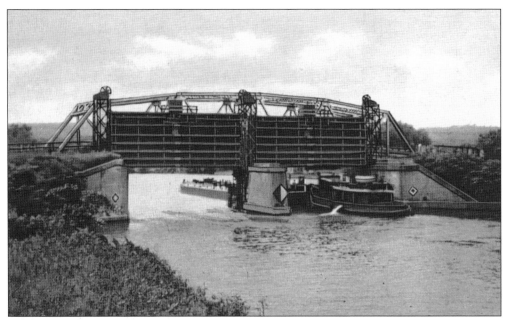

The water level in the Barge Canal is maintained by control dams. This gate at Herkimer can be moved when necessary to monitor water depth at different times of the year.

Travel by road was primitive before automobiles made pavement a necessity. Spring and autumn rains made dirt roads muddy. This portion of Small's Bush Road (crossing Beaver Brook in East Herkimer) looks like it is in good condition.

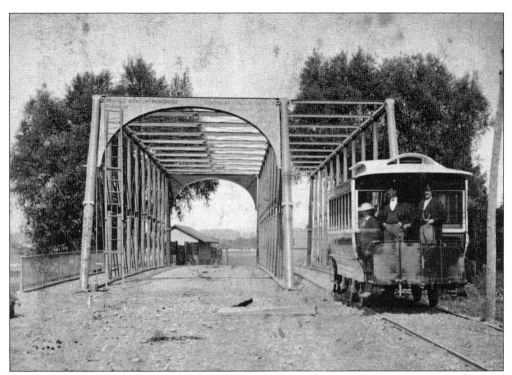

This trolley bridge allowed trolleys to pass over the river from Mohawk to Herkimer. The earliest trolleys were horse-drawn. By 1872, it was possible to ride an electric streetcar from Frankfort to Herkimer. (Courtesy Lillian Gaherty.)

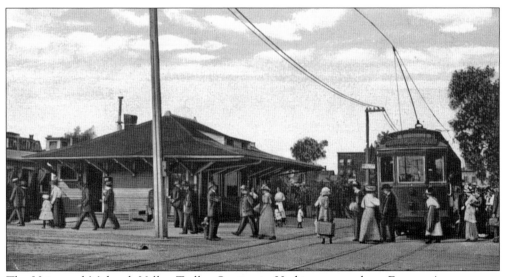

The Utica and Mohawk Valley Trolley Station in Herkimer was where Eastern Avenue once met South Main Street.

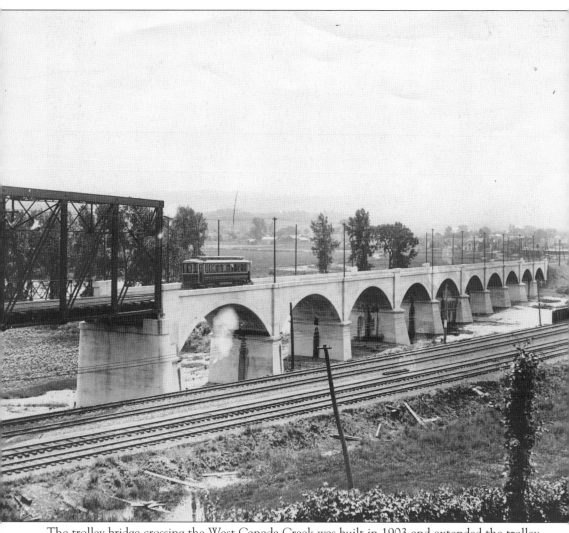

The trolley bridge crossing the West Canada Creek was built in 1903 and extended the trolley line (then known as the New York State Electric Railway) from Utica to Little Falls. The bridge was 1,212 feet overall, with 10 concrete arches and a 225-foot steel span costing $500,000. The street railway operated until 1933.

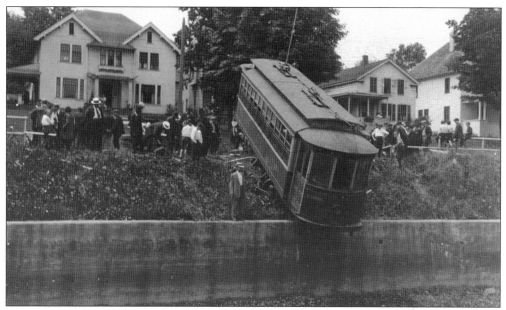

On a sunny day in 1920, a trolley derailment in front of 273 West Main Street in Ilion caused this gathering of curious citizens.

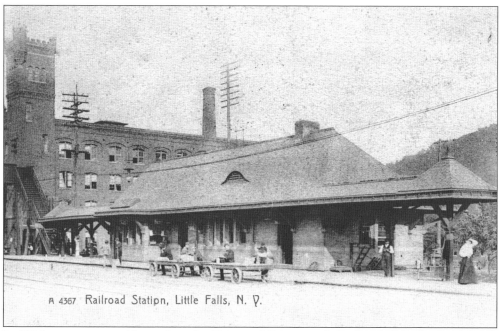

A 4367 Railroad Station, Little Falls, N. Y.

In 1836, passengers could travel on the Utica and Schenectady Railroad through the Mohawk Valley towns. By 1874, the New York Central Railroad, the world's first four-tracked railroad, was operating in the valley. Depots and crossings were familiar sights. This picture shows the Little Falls Station, now serving as a restaurant.

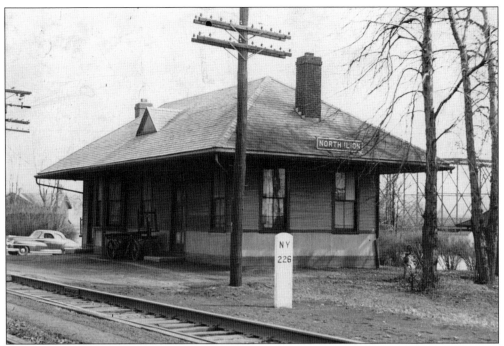

In this photograph of the depot at North Ilion, note the bridge on the right. The New York Central Railroad called its New York–Chicago main line "the water level route."

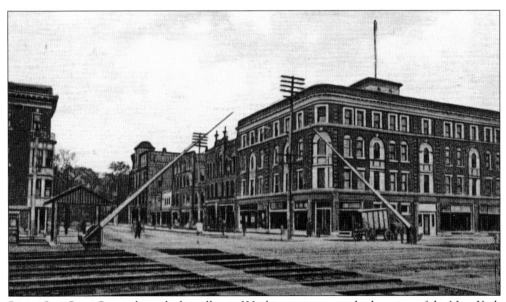

Route 5, or State Street through the village of Herkimer, was once the location of the New York Central tracks. This view, looking north, shows the Main Street crossing. Note the pedestrian walkways across the tracks.

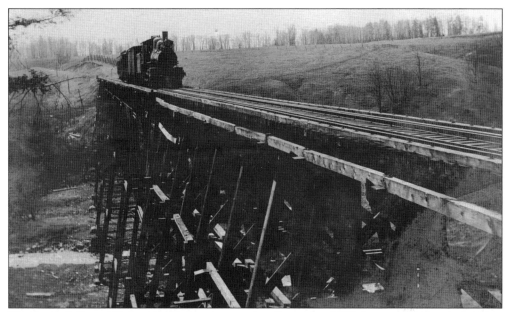

The Little Falls and Dolgeville Railroad opened in December 1892. It connected with the New York Central at Little Falls. By 1913, the New York Central was operating this branch and renamed it the Dolgeville Branch. A spur to the Irondale mines in Salisbury ran from 1908 to 1913. Passenger trains ran on the Dolgeville Branch until 1933, and freight was carried until 1964.

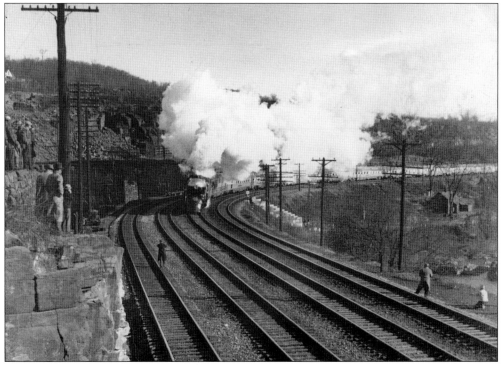

The sharpest curve in the New York Central system was the Gulf Curve at Little Falls. The speed limit was 45 miles per hour.

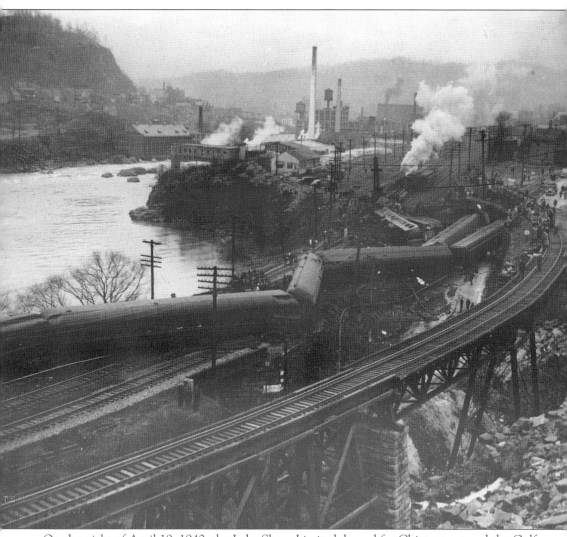

On the night of April 19, 1940, the Lake Shore Limited, bound for Chicago, entered the Gulf Curve going 59 miles per hour. The locomotive jumped the track and hit a rock wall. The death toll was 31, with more than 125 people injured. Daylight brought a terrible sight to onlookers.

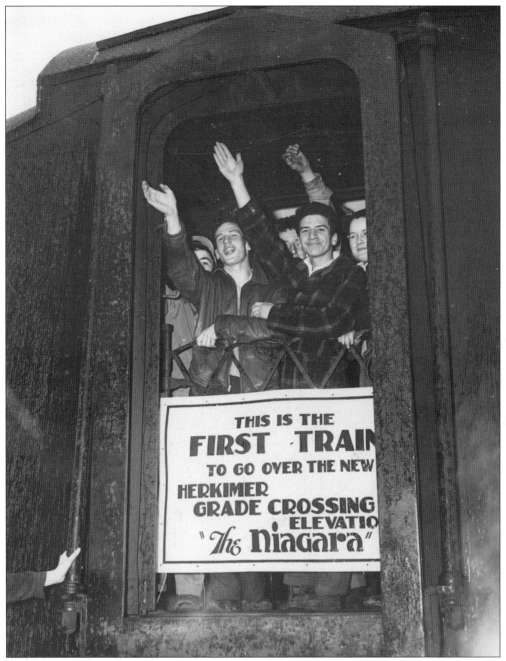

In 1943, the railroad tracks were moved from State Street in Herkimer closer to the river. A celebration was held when the first train passed over the new route. Officials cut a ribbon in front of the locomotive. These happy young men were riding in the last car.

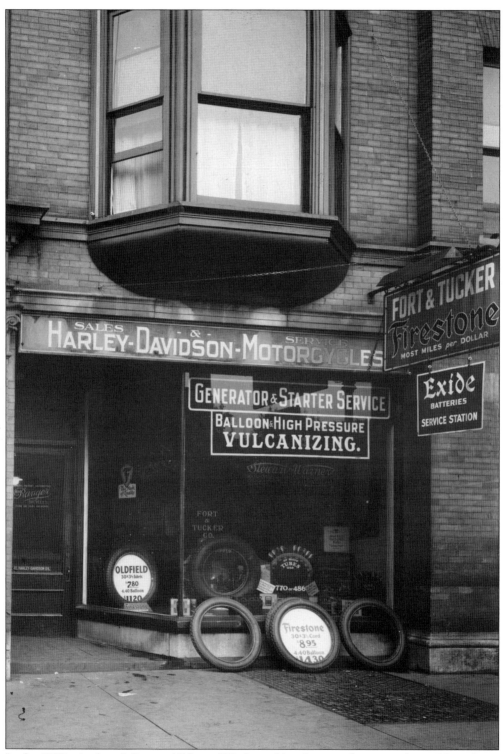

In the 1920s, Andrew J. Fort and Edmund Tucker sold and serviced motorcycles and bicycles at 305 North Main Street in Herkimer.

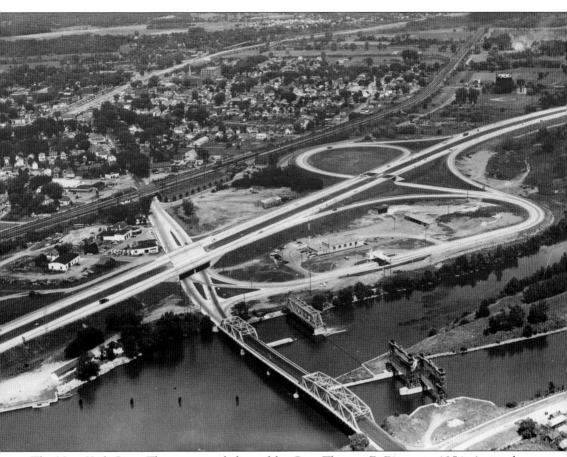

The New York State Thruway was dedicated by Gov. Thomas E. Dewey in 1954. Again the Mohawk Valley provided a passage for an important transportation route. This photograph shows interchange 30 as it appeared at Herkimer in 1957. About 60 Herkimer County farms were appropriated for the thruway route. The buildings and grounds of interchange 30 occupy the sites of the old Herkimer County fairgrounds, the Carroll swimming pool, and a small airstrip. Little Falls later received interchange 29A near the Herkimer Home Historic Site. The thruway was named in honor of Thomas E. Dewey.

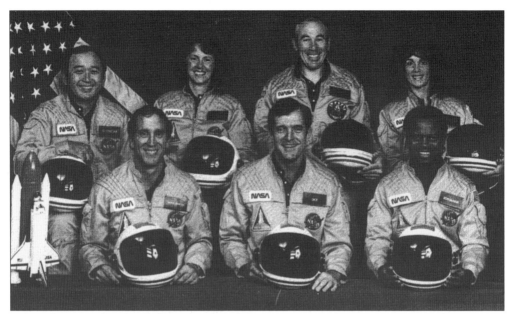

When the space shuttle *Challenger* exploded during its ascent from Cape Canaveral on January 28, 1986, Mohawk native Gregory B. Jarvis met his death with the other crew members. Pictured here, from left to right, are the following: (front row) Michael J. Smith, Francis R. Scobee, and Ronald E. McNair; (back row) Ellison S. Onizuka, Christa McAuliffe, Gregory B. Jarvis, and Judith A. Resnick. Jarvis was an engineer at Hughes Aircraft Company.

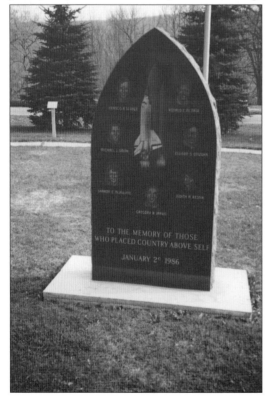

Challenger Park in Ilion is a memorial to the seven men and women killed while taking part in America's space program. Many people and organizations contributed to the creation of this monument, which is owned and maintained by the Ilion Kiwanis. Mohawk High School was named the Gregory B. Jarvis High School, and the New York Power Authority dedicated the Gregory B. Jarvis Power Plant at Hinckley.

Four

ABUNDANT LAND AND LABOR

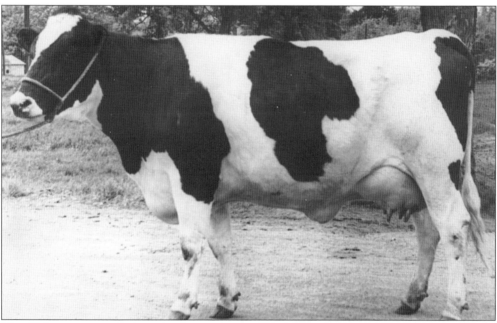

This Holstein cow symbolizes the dairy industry of Herkimer County. Wheat was the main crop of early settlers. Corn was a staple, eaten by people and farm animals. As people moved west, they found land more suited to growing grain, and local farmers found that dairying was the most profitable type of agriculture for their valley. Herkimer County cheese became world famous. By 1875, the Little Falls Cheese Market was thriving. More than seven million boxes of cheese were shipped out of the county annually. Railroads made it possible to ship milk to the New York City area, and farmers carried their milk to the milk stations along the railroad. Later, bulk tanks were installed, and tank trucks now carry the milk from farm to processing plant.

The location of this mill is unknown, but it indicates the need of early settlers for mills to saw logs and grind grain. The town of Schuyler was first occupied by Germans recruited by Peter Hasenclever in 1765. Their settlement, located in East Schuyler, was called New Petersburg.

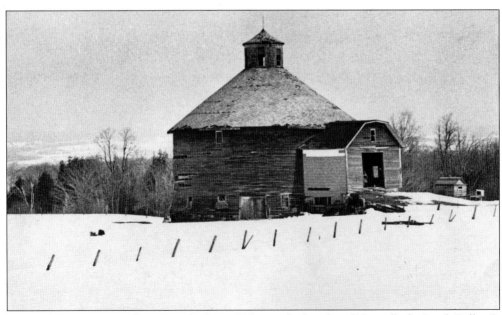

The Zoller-Frasier Round Barn was built c. 1895 near the hamlet of Newville for Jacob Zoller. It was listed on the National Register of Historic Places as an unaltered example of a round barn. Dairy herds were sheltered here for close to a century before its demise.

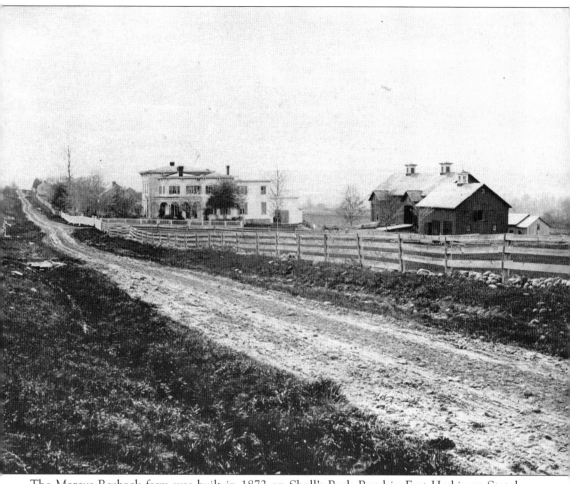

The Marcus Rasback farm was built in 1872 on Shell's Bush Road in East Herkimer. Stately farm homes could be found on unpaved country roads. Hired hands frequently boarded in the family home, as farm maintenance required many workers. Stones are visible to the right by the fence. Stone walls often marked the boundaries of farms, as they were readily available, appearing in the fields every spring.

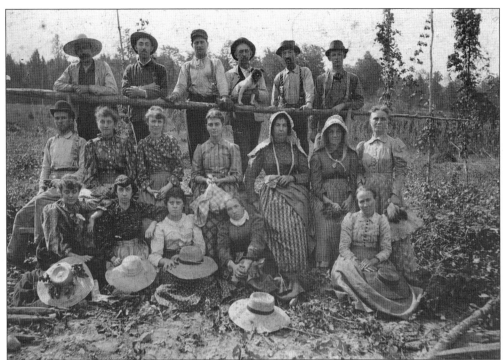

A group of hop pickers poses c. 1890. The women have sun bonnets, and several of them are holding work gloves. Hops were harvested from vines in September, and people of all ages gathered to pick this cash crop necessary for brewing beer.

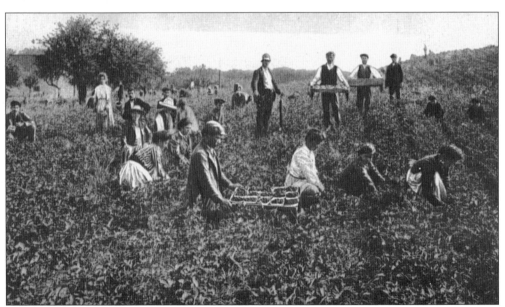

The flat lowlands near the Mohawk River are fertile and have milder winters than the hills surrounding the valley. These strawberry pickers are working in Frankfort. Farmers in the towns of Schuyler and Frankfort grow berries and vegetables today, their products marketed in groceries and roadside stands. (Courtesy George Dieffenbacher.)

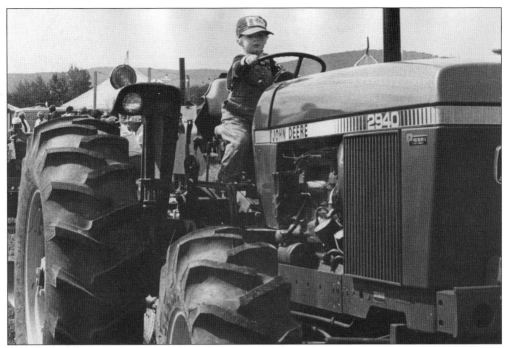

A young boy is trying out a tractor at the Herkimer County Fair of 1983. As farm equipment improved, fewer workers were needed to farm greater acreage. The number of small family farms decreased and farm children moved to industrial areas for employment.

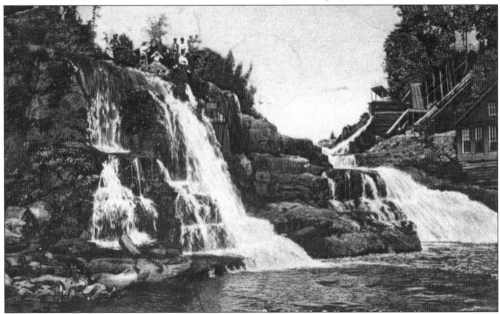

Beardslee Falls, in the town of Manheim, was named for John Beardslee, who settled along the East Canada Creek and built a mill in 1790. He also built the first county courthouse and bridges over the Mohawk. His son Augustus Beardslee was a judge and served in the state legislature. John's grandson Guy Roosevelt Beardslee developed hydroelectric power, which was transmitted as far as Canajoharie.

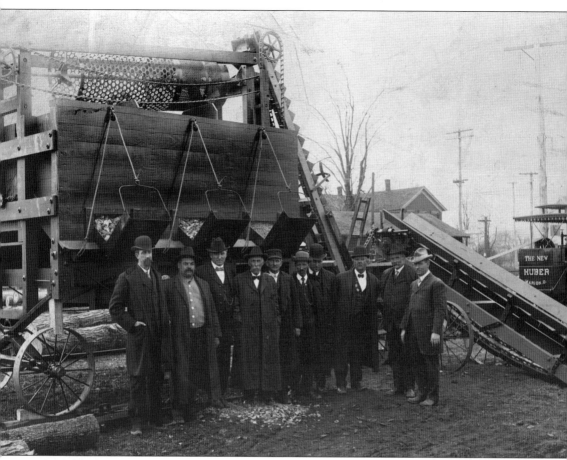

A group of men poses in front of a stone-crushing system in Frankfort. Limestone is found in many places in Herkimer County. In the southwestern portion of the town of Frankfort were several limestone ledges, the most important being Horsebone Ledge according to John Homer French's *Gazeteer* of 1860. This picture was taken *c.* 1920. On the right is the steam engine that powered the crusher. The stone was placed on the conveyor to the crusher. From the crusher, it was transported by a bucket conveyor to the rotating screen, where it was sized and dropped into hoppers behind the men.

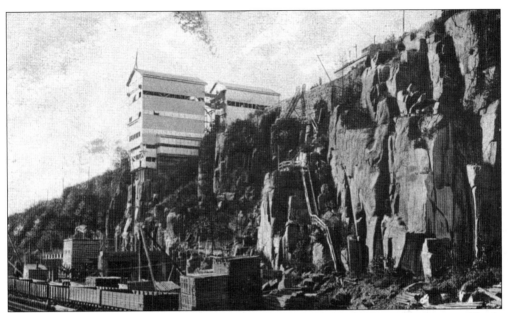

The Pierce Stone Company was on the north side of the river, at the Burnt Rocks east of Little Falls. Two loading tracks had gravity-dump loading chutes that allowed 20 hoppers to be filled at once. This company began in 1921 and closed in the 1930s. It helped to meet the demand for crushed stone for surfacing roads.

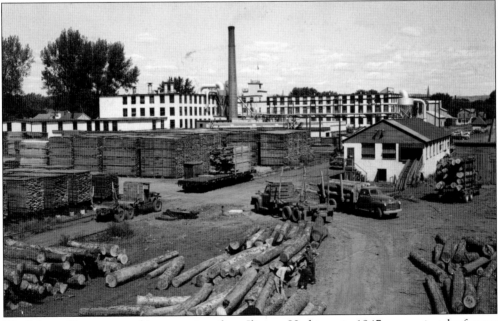

The Library Bureau moved its operations from Ilion to Herkimer in 1947, occupying the former quarters of the National Desk Company. Part of Remington Rand, the Library Bureau became a division of Sperry Rand and built a large addition in 1956, producing high-quality library furniture and museum cases. In 1977, local stockholders purchased the company and it was called Library Bureau Division of the Mohawk Valley Community Corporation. Finally, the plant was razed, and a Wal-Mart now occupies this site.

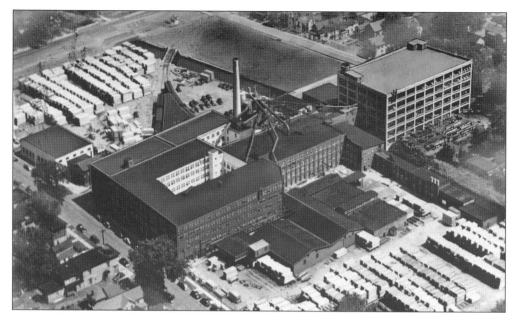

The Standard Furniture Company of Herkimer, founded in 1886, was once the largest manufacturer of wood office desks and furniture in the country. The company conducted lumbering operations and operated sawmills in the North Country, making it possible to advertise a Standard desk as "from forest to finished product." After several changes of ownership, the company closed in 1976. Most of the buildings were razed in 1978.

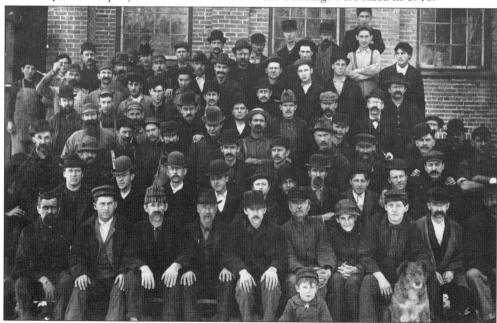

Horrocks Desk Company workers pose in 1898. By 1922, Horrocks Desk, National Desk, Standard Furniture, and the F.E. Hale Manufacturing Company were producing one third of all desks made in the United States. The Horrocks Desk Company was originally on West German Street and, in 1903–1904, in a four-story factory on East German Street in Herkimer. It was discontinued in the 1930s.

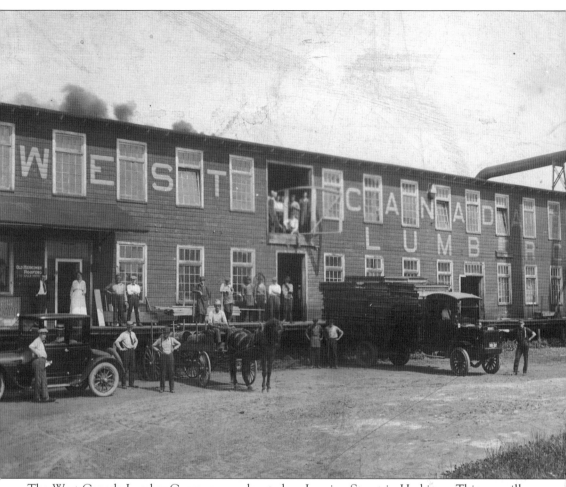

The West Canada Lumber Company was located on Lansing Street in Herkimer. This sawmill and that of C.R. Snell and Sons Company supplied the desk manufacturers with lumber. Operations were noted in the 1929 business directory. Following the Great Depression, the company was no longer in business.

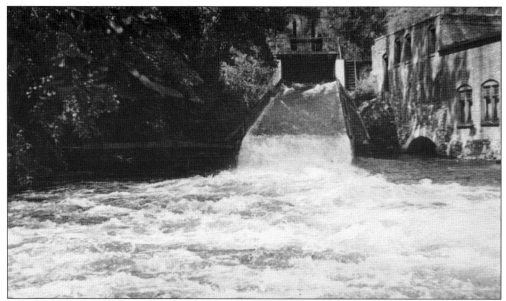

The Hydraulic Canal was completed in 1835 to provide waterpower from the West Canada Creek for industrial purposes. A wooden dam was built on the creek, north of Herkimer. A canal led the water to a basin formed by a natural lake. This picture shows the upper drop where the Herkimer Paper Company was later located. The canal brought water through the village to the lower drop at the present Eastern Avenue, providing power for Col. Frederick B. Bellinger's gristmill, and then into the Mohawk River.

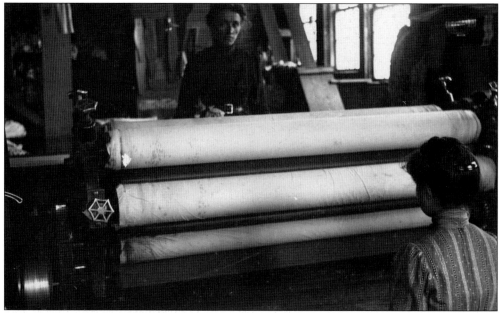

The International Paper Company purchased the Herkimer Paper Company in 1898. This company owned more than 30 paper and pulp mills. These women are employed in folding paper c. 1900. After a series of owners, the company ceased operations in the early 1970s. The Pennsylvania Egg Carton Company was the last property owner. In the 1990s, part of the canal was filled in for a parking lot for county employees.

The forge where Eliphalet Remington II made the first Remington gun was located on Steele's Creek, which flows through the Ilion Gorge. After he forged the gun barrel in 1816, he took it to Utica for a gunsmith to ream and rifle the barrel. By the mid-1820s, this forge had five waterwheels and made axes, wedges, plowshares, crowbars, and gun barrels. This forge was built by Eliphalet Remington I and was transferred to his son in 1820.

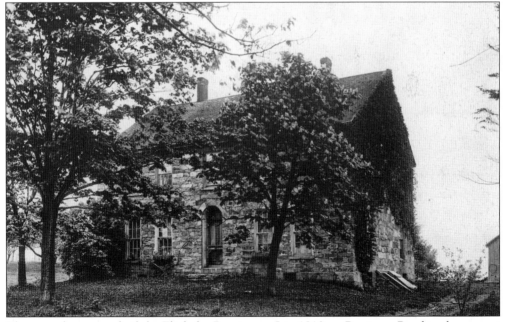

The stone house was built by Eliphalet Remington I in 1810 on Barringer Road in the present town of Frankfort. Remington II lived here for a time, and his son Philo was born here in 1816. They later moved nearer the forge. In 1828, Eliphalet Remington II moved operations to Ilion, where he supplied rifle barrel blanks to gunsmiths.

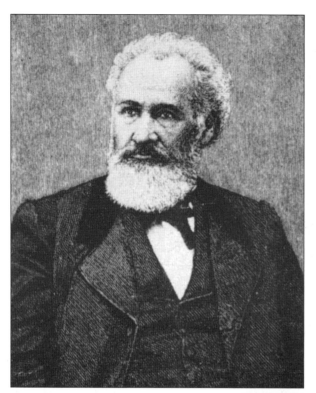

Philo Remington entered the business in 1837, and it became known as E. Remington and Son. By this time, his father had built a large frame factory along the Erie Canal in Ilion, producing gun barrels exclusively. Brother Samuel joined the firm in 1839. When Eliphalet Remington II died in 1861, the management of the company was undertaken by Philo.

Eliphalet Remington III joined the firm, now E. Remington and Sons, in 1856. The company was expanding rapidly, an armory being added in 1844 and other buildings in 1848. An 1845 contract for 5,000 Model 1841 rifles, later called Mississippi rifles, fueled the expansion of the company. Following the Civil War, other products were added—sewing machines, agricultural implements, and bolt-action rifles, as well as typewriters.

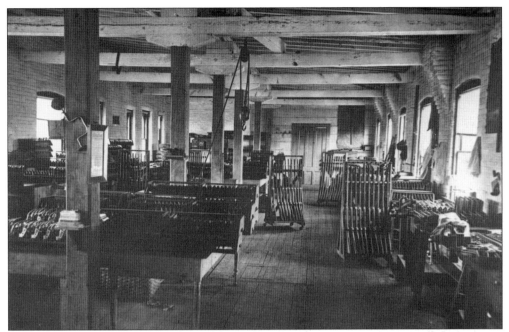

By the close of the Civil War, Remington was one of America's largest arms manufacturers. In 1856, Fordyce Beals received a patent for the first handgun made at the Remington Armory. By 1865, percussion revolvers for civilians were in production.

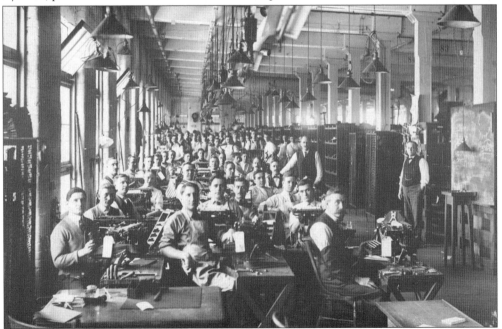

Workers are assembling typewriters *c.* 1913. Philo Remington started production of typewriters in 1873. Only capital letters could be typed until Remington employees invented a shift key. In 1886, Philo sold the typewriter business to Wycoff, Seaman, and Benedict, who retained the Remington name. A new factory was built and, by 1902, some 1,500 employees were producing 50,000 machines a year.

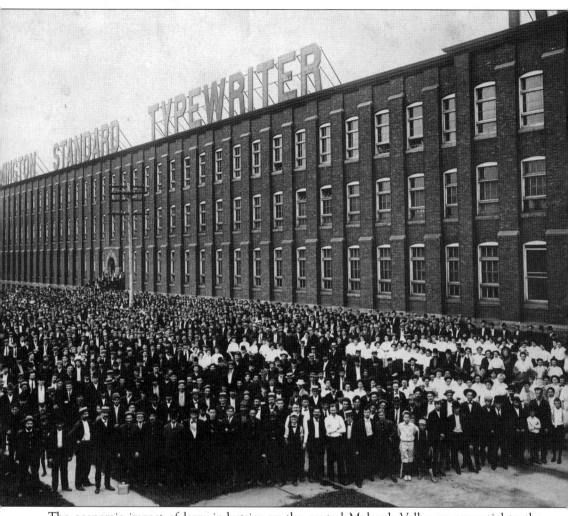

The economic impact of large industries on the central Mohawk Valley was essential to the growth of the valley towns. The company was merged *c*. 1928 with nine other firms and was called Remington Rand. In 1936, workers went on strike to protest the company's refusal to recognize the Office Equipment Workers' Union. The strike ended in 1937, but the company did not immediately rehire the employees, as agreed to in the strike settlement. The typewriter industry was removed from Ilion. Key punches, tabulators, and card sorters were then manufactured.

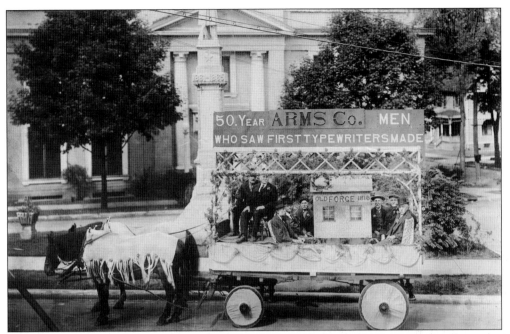

The Remington Typewriter Company celebrated its 50th year of typewriter manufacture in 1923. The men on the float were present at the making of the first Remington typewriter in 1873. This picture was taken in front of the Ilion Masonic Temple, home of the Free and Accepted Masons, No. 591, since 1909.

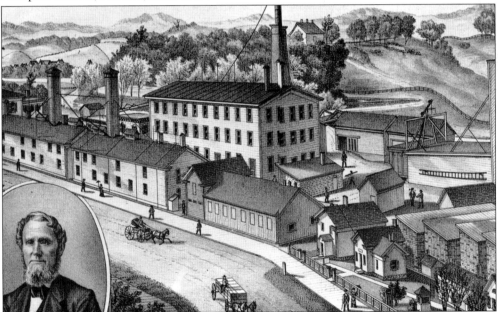

When William Gates moved to Frankfort in 1843, he had the idea of developing a convenient source of friction to produce fire. He perfected a phosphorous mixture for match heads in 1844. By 1855, Gates patented the first continuous match machine. Two and a half million matches a day were being made in Frankfort by 1859. In 1893, Gates's son sold the business to the Diamond Match Company.

Henry Marcus Quackenbush (1847–1933) was born in Herkimer and learned mechanical skills while employed at Remington Arms. He experimented at home on Prospect Street in Herkimer, where he produced a wooden-framed velocipede and invented the extension ladder, patented in 1867. By 1871, the H.M. Quackenbush Company had been born. An early success was an air pistol, followed by air rifles. A local dentist, Dr. Clinton Chatfield, asked Henry to produce a dental pick he had designed. This led to the development of a nut pick and the beginning of the Quackenbush nutcracker.

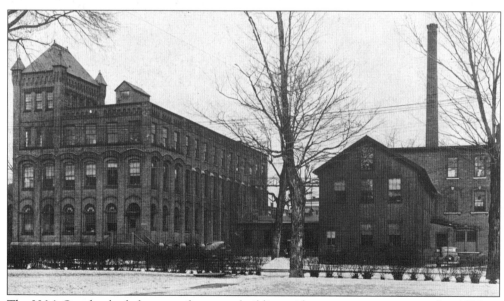

The H.M. Quackenbush factory, a four-story building with a tower, was constructed in 1890 on Prospect Street and employed 100 men. Gun manufacturing ended after World War I. During World War II, war-related products were produced. In 1987, a large building was added on North Main Street to house the electroplating business.

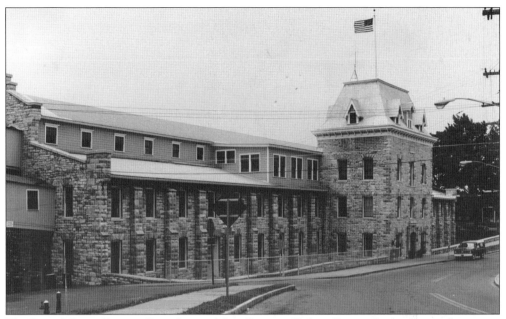

The Daniel Green Factory Complex, on Main Street in Dolgeville, was built of native limestone over several years by Alfred Dolge. By 1881, two stone boiler houses were added and an iron bridge connecting the factory to the lumberyard on Dolge Avenue was built. The second electric dynamo made by Thomas Edison was installed in the factory, where felts and piano hammers were being produced. By 1881, felt shoes and slippers were the major products.

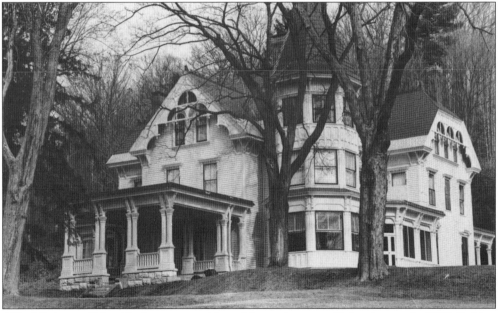

Alfred Dolge and his wife, Anna, moved into this new home on Dolge Avenue in 1895. Stables, greenhouses, 40 rooms, and a terrace and rock gardens made this residence a palace. Alfred Dolge was a pioneer in labor management, working to improve the lives of local residents. A financial reversal related to his investment in the Little Falls-Dolgeville Railroad caused him to leave Dolgeville. The factory was acquired by the Daniel Green Felt Shoe Company.

Frank J. Vincent began to manufacture mattresses in this plant (on Southern Avenue in Little Falls) in 1892. In 1952, his son Neely Vincent moved the business to the old Phoenix Mill on West Mill Street. Currently, the business is on East Mill Street. Alan Vincent, grandson of Frank Vincent, is the company president.

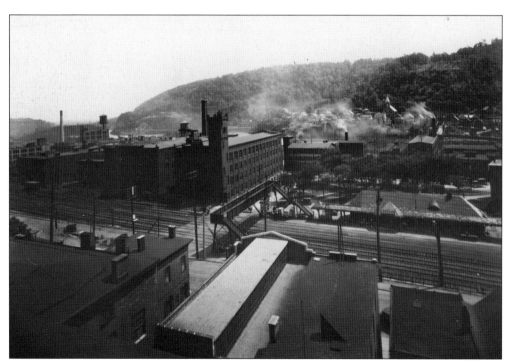

The railroad depot in Little Falls and Clinton Park were in the industrial section of the city. Clinton Park was the site of the Erie Canal Basin and was given to the city by Arphaxed Loomis. The 1903 city directory lists the mill in the center of the photograph as Robert MacKinnon and Company, knit goods. It was later known as the Phoenix Underwear Company. The Phoenix mills and Gilbert Knitting Company were hit by a textile workers' strike in 1912.

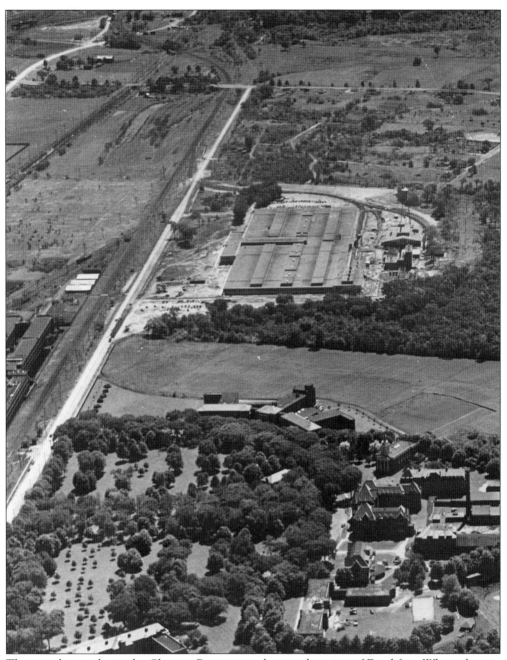

This aerial view shows the Chicago Pneumatic plant in the town of Frankfort. When plans to build this plant were announced in 1948, people welcomed the new industry. It was built on the site of Forest Park (formerly the old Utica Park) just east of the Utica city line and opened in 1949. During the 1950s and 1960s, employment fluctuated between 1,000 and 2,200. Air-driven and electric-driven magnamatic screwdrivers and nut runners were developed and built. In 1997, operations were moved to South Carolina with a loss to the Mohawk Valley of 430 jobs. At that time, Chicago Pneumatic was producing air-powered tools for the auto and aircraft industries. The Utica Masonic Home is visible in the foreground of this photograph.

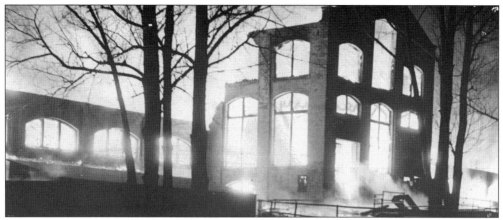

The Pratt-Chuck Company of Frankfort burned in 1943. This company moved to Frankfort from Clayville in 1897. The company had a patent for improved drill chucks and Empire friction chucks.

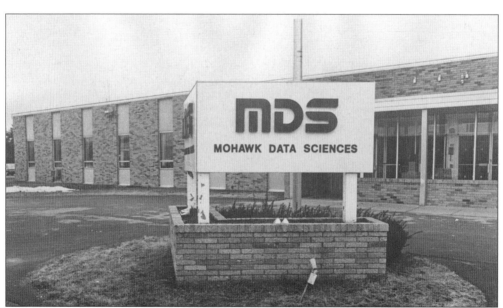

Mohawk Data Sciences, formed in Ilion in 1964 by Univac employees, produced a machine that allowed operators to put source data directly on magnetic tape. The data recorder eliminated key-punch machines and card readers. This plant in East Herkimer employed hundreds. New technology passed by the data recorder and, by 1990, the buildings and equipment of Mohawk Data Sciences were sold at auction.

Five

HOMETOWNS

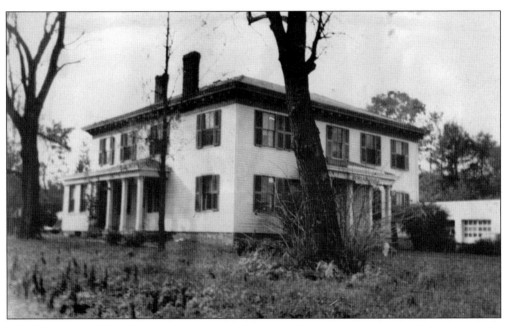

The Shoemaker Tavern, on Main and Richfield Streets in Mohawk, was said to have been built in 1768 by Rudolph Shoemaker. Used as a Tory meeting place, it was the site of Walter Butler's capture. (Butler, a notorious Tory, later escaped from an Albany jail.) George Washington had lunch on the lawn under a tree on July 28, 1783, while on his way to tour Fort Stanwix. This building was designated a historic site in 1933 and was later known as the Valley Tavern. It burned down in 1973.

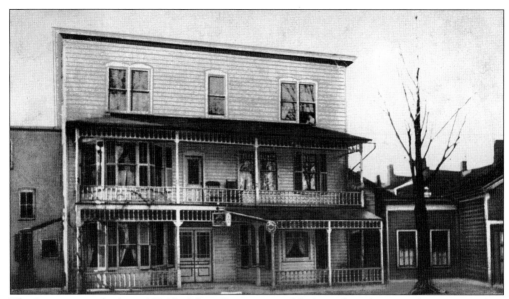

The Lovejoy was built in 1886 by Harry Lovejoy as a blacksmith and wagon shop. Located on Columbia Street, it was said to be a Temperance Hotel by 1895. It was last operated by Harry Harter. From 1926 to 1961, it served as Mohawk's municipal building. In 1961, the Lovejoy was razed.

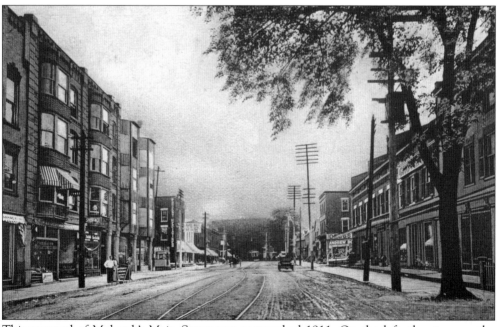

This postcard of Mohawk's Main Street was postmarked 1911. On the left, the store on the corner has white letters that read, "Patent Medicines." This sign is also visible in another scene, dated 1858.

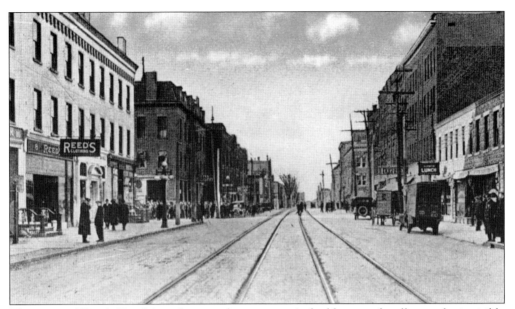

This view of Ilion's East Main Street is facing west. A double row of trolley tracks is visible down the center of the street. Reed's Clothing Store is on the left.

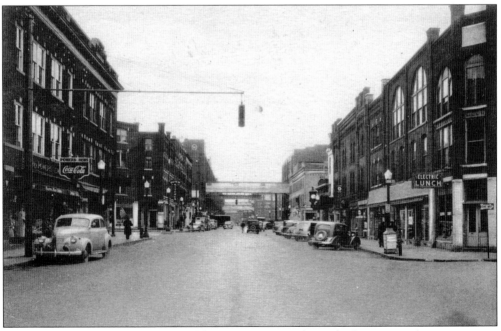

Looking east, this early-1940s view of Ilion's Main Street shows the Remington Arms overpasses crossing the street.

Ilion's Bridge Square was formerly along the banks of the Erie Canal. A.A. Morgan had a coal business that supplied Remington Industries. The coal was brought in horse-drawn barges and stored in sheds between the canal and Main Street, from the foot of First Street to the foot of Morgan Street.

Ilion's Monument Square features a granite soldiers' monument commissioned in 1905 by the Grand Army of the Republic and Woman's Relief Corps. It was designed and made at the Alexander Jarvis Monument works in Ilion. A Union soldier faces Armory Hill Cemetery, resting place of many Union soldiers.

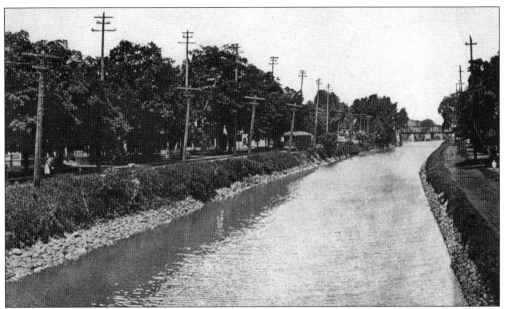

Pleasant Avenue in Frankfort ran parallel to the Erie Canal. The former canal area is now covered by long blocks of grass.

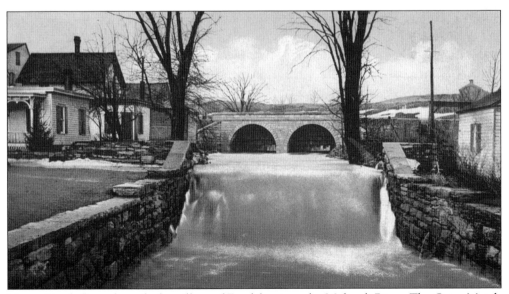

Moyer Creek flows through the village of Frankfort into the Mohawk River. The Gates Match Factory was located on its eastern bank. During spring thaws, residents watch this creek for flooding.

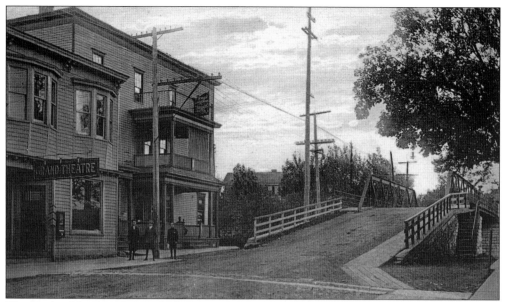

The Bridge Hotel and Grand Theatre were situated on Litchfield Street in Frankfort, near a bridge over the Erie Canal. Note the pedestrian walkway over the bridge and the stone bridge abutments.

The Union Block, on the corner of Litchfield and West Main Streets in Frankfort, was destroyed in a fire. The police department was formerly located behind this building, visible on the far right. The Union Block replaced the Joslin Block, which burned to the ground in 1912.

Stately homes lined Dolge Avenue in Dolgeville. The Alfred Dolge factory buildings may be seen in the background. In 1875, Dolge established a lumberyard on this avenue.

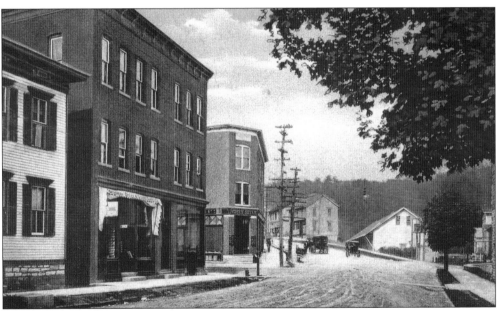

Dolgeville's Main Street shows the buildings opposite the former Daniel Green main office. On the far left, the Niagara-Mohawk Power Corporation office and a jewelry store shared the first floor. The local telephone exchange operators were on the second floor. The corner building housed a stationery store and a five-and-dime. Upstairs was the dental office of Dr. Claude Malson. Across Elm Street was the Morris Gennis Building, which housed the post office and DelVeccio's Shoe Store. It burned in May 1963 and was replaced by Helterline Park. (Courtesy Dolgeville-Manheim Historical Society.)

The Alfred Dolge Hose Company No. 1 hose house is on South Main Street in Dolgeville. In 1879, Alfred Dolge helped modernize the Dolgeville Fire Department by founding the Volunteer Fire Department No. 1, which was later named for him. The hose house is now the museum and meeting place of the Dolgeville-Manheim Historical Society. Collections include Dolge family books, photographs, local history, and information on volunteer firemen, local servicemen, churches, schools, and businesses. (Courtesy Dolgeville-Manheim Historical Society.)

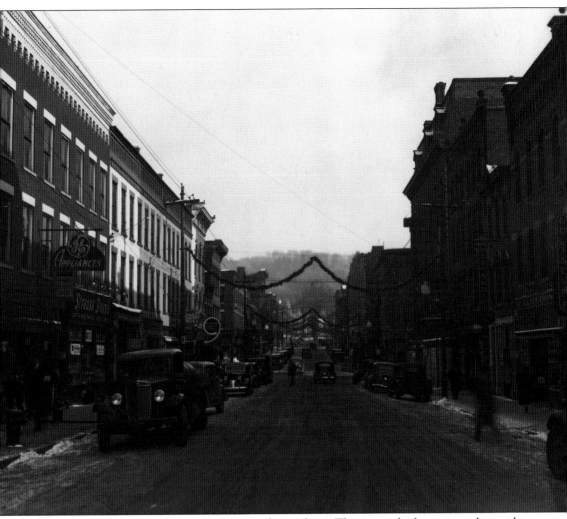

Main Street in Little Falls c. 1937 was a busy place. This view, looking east, shows the numerous shops that lined the business district. As part of the city's urban renewal, a $1 million shopping center called Shoppers Square was built on the south side of Main Street in 1965–1966. Traffic patterns were changed, making Main Street one-way. This photograph was taken by F.E. Abbott.

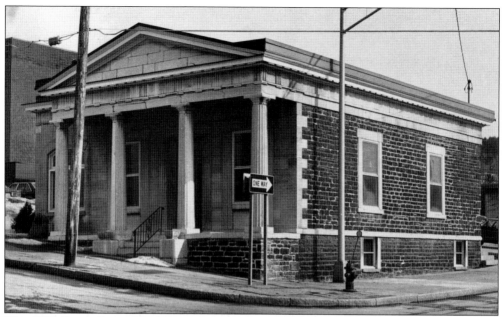

This 1833 Greek Revival building was erected for the Herkimer County Bank, predecessor of the Herkimer County Trust Company. The Little Falls Historical Society, chartered in 1963, maintains a museum and archives in this historic register building, which survived urban renewal. It is near the former site of the open-air cheese market that peaked in 1878.

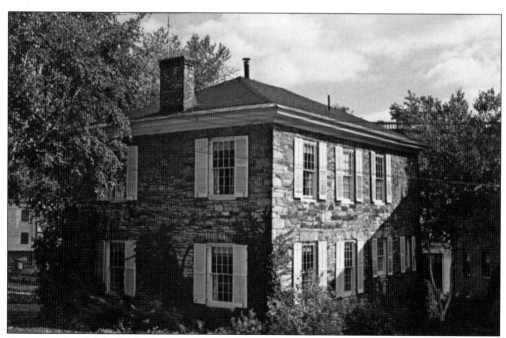

Known as the Adelaide C. Vincent House, this limestone Georgian structure was built in 1814 to replace a 1796 wooden school on this site on Church Street in Little Falls. Church services were also held here for a time.

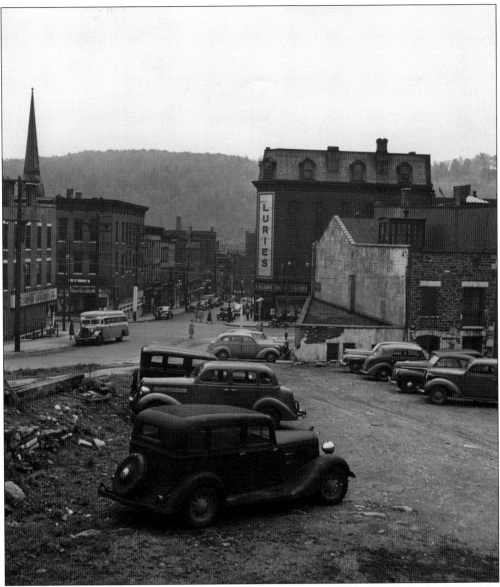

In the foreground is the parking lot maintained by Orval Hall, who had a Dodge-Plymouth-Valiant agency at his garage on the southwest corner of Second and Garden Streets in Little Falls. Lurie's store, a fixture for more than 50 years, did not remain in Little Falls. The buildings behind the bus were demolished to make way for Shoppers Square.

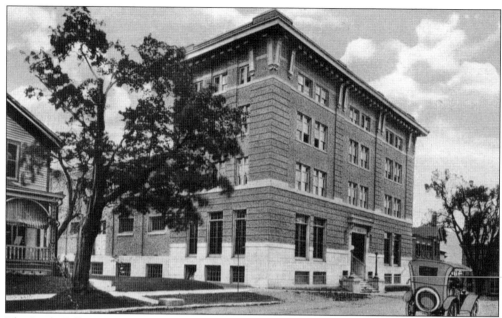

The Little Falls YMCA building was the Presbyterian parish house when it was built in 1911. The Burrell family, of dairy equipment fame, were benefactors. In 1913, the building was opened to the public as the Citizens Association Building.

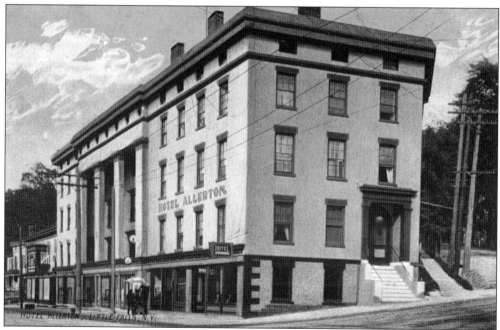

The Allerton Hotel, on the corner of Main and Ann Streets in Little Falls, was later known as the Richmond. In the 1930s, it became the Hotel Snyder and is currently the Snyder Apartments.

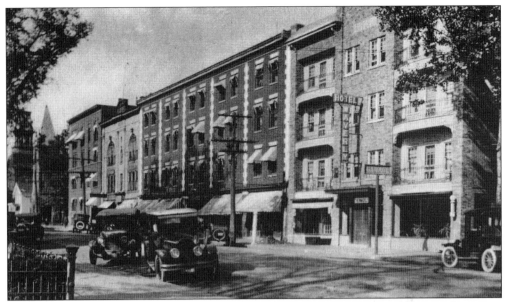

Constructed in Herkimer *c.* 1858 on the site of an 1800 hotel, this hotel became known as the Waverly House until 1936, when the name was changed to the General Herkimer Hotel. Among its famous guests were Gov. Franklin D. Roosevelt, Robert Kennedy, and Gov. Nelson Rockefeller. Numerous improvements and the addition of the General Herkimer Inn Towne Motel continue the story of this hotel.

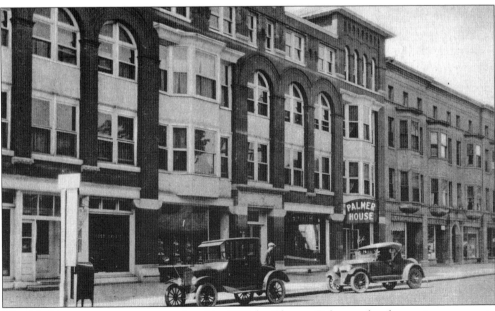

This Herkimer structure was completed in 1891 by Chester Palmer, a hardware store owner, to replace the former hotel erected by P.M. Hackley in 1826. Considered one of the state's finest hotels, it accommodated the Gillette murder case jurors, visiting judges, and celebrities.

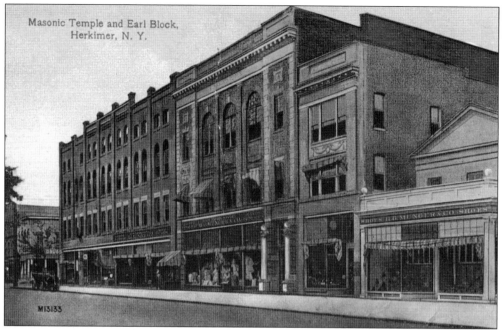

The Earl Block in Herkimer housed H.G. Munger's Department Store, the Bradley and Zeitler Drug Store (on the corner), Wilkinson's Saloon (on the Green Street side), and numerous business offices. A disastrous morning fire in February 1917 destroyed the Earl Block and its neighbors.

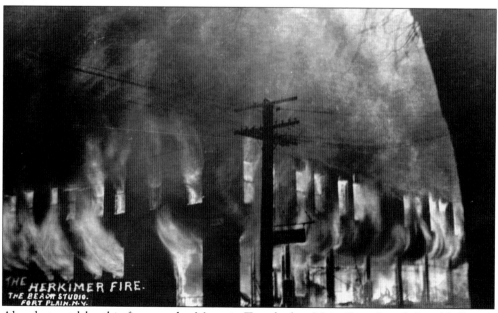

Also destroyed by this fire was the Masonic Temple (on Main Street) and the old Grange Temple (on Green Street), which housed the Evening Telegram. One woman perished, and buildings on the north side of Green Street suffered heat damage.

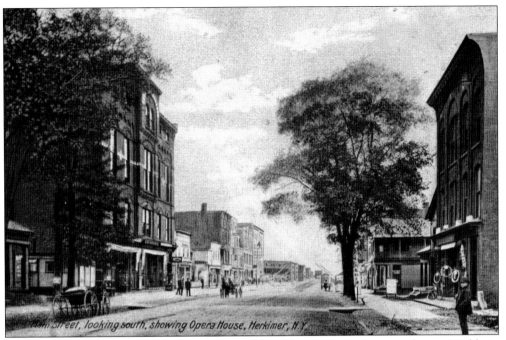

This view, looking south on Herkimer's North Main Street, shows the opera house. Visible in the background are the railroad crossing gates that protected Main Street travelers.

A later view of North Main Street shows the Liberty Theater, built in 1918 after the Great Fire. The owners were Robert Earl, Charles T. Gloo, and Charles H. Moyer. Schine Enterprises purchased the theater in 1926. An orchestra and pipe organ provided music when necessary.

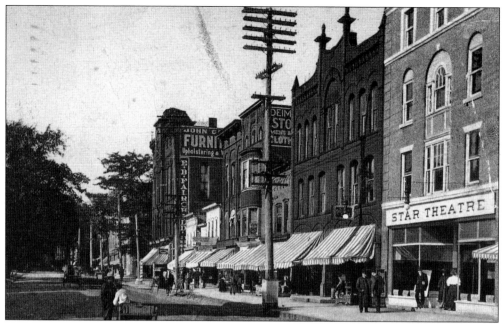

The Star Theatre was located on Herkimer's North Main Street. In 1908, wooden benches provided the seating.

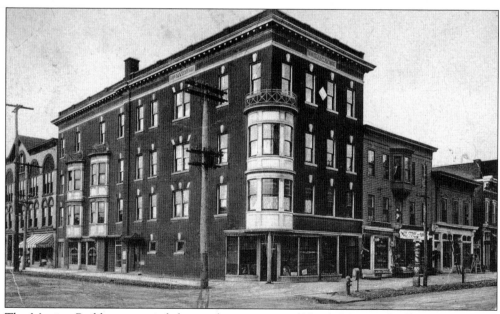

The Manion Building occupied the northwest corner of North Main and Albany Streets and later burned down. The Nelson House was on the northeast corner.

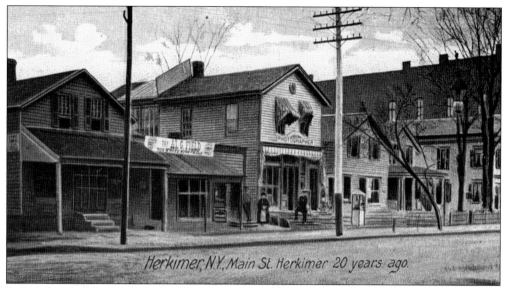

Before the Earl Block was built, these businesses occupied the site. From left to right are M.M. Draper's bake shop and restaurant; Louis Turner's meat market and Henry Voight's tailor shop (together); a building that had Koonz photographic studio upstairs, John Zintsmaster's harness shop downstairs, and a saloon in the basement; a cobbler shop and sewing machine business; and the opera house.

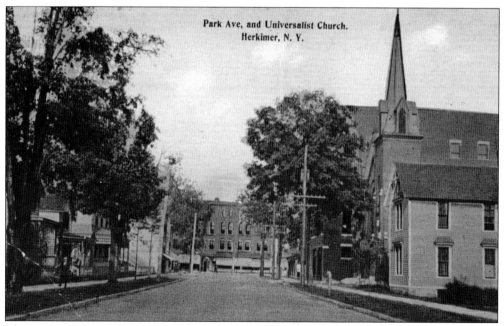

This postcard shows Park Avenue in Herkimer as it was before 1917. Visible in the background is the ill-fated Earl Block.

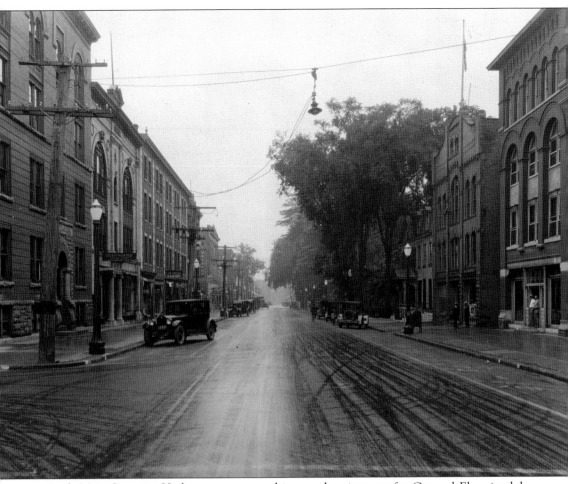

North Main Street in Herkimer is portrayed in an advertisement for General Electric globes for lampposts. From left to right are the Van Kirk Apartments, Devendorf Tailor Shop, Haynes Bakery, a five-and-dime, and the Waverly Hotel.

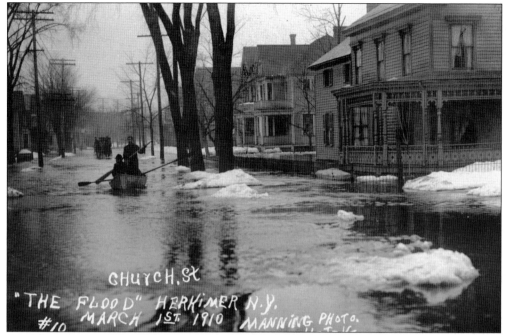

On February 28, 1910, the West Canada Creek broke out of its banks, and blocks of ice and freezing water flooded Herkimer. A few days of unseasonable temperatures caused a thaw, and the West Canada became a raging torrent as it roared to its meeting with the Mohawk River. Church Street was navigated by rowboats.

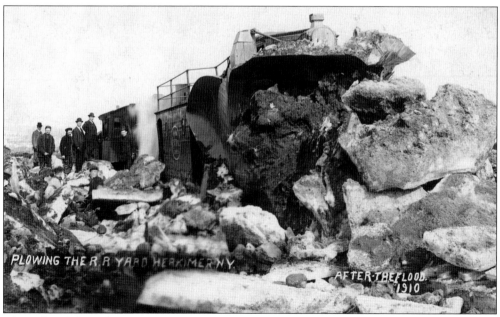

The railroad through Herkimer was in the path of the flood. Huge ice chunks were plowed out of the railroad yard.

On the corner of Church and Prospect Streets in Herkimer was the Mark mansion, now the site of Temple Beth Joseph. Morris Mark produced knit shirts. A distillery occupied this site before the Mark mansion.

The Cornelius Reuben Snell home was opposite the General Herkimer Hotel. Snell was a lumberyard owner, an organizer of the First National Bank of Herkimer, and served in many other capacities. The Frank J. Basloe Library now occupies this site.

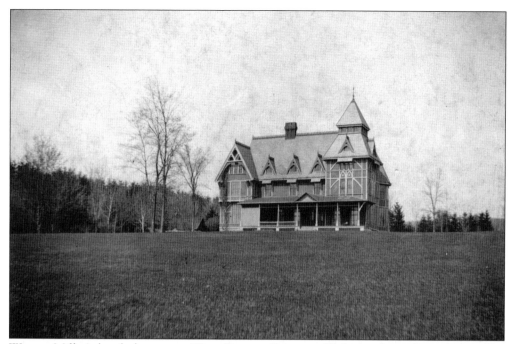

Warner Miller's lovely home, on West German Street in Herkimer, burned in 1930. Miller developed a new process for making paper from wood pulp while owning the Herkimer Paper Company. He was elected to Congress in 1878 and was appointed to the Senate in 1881 to fill an unexpired term.

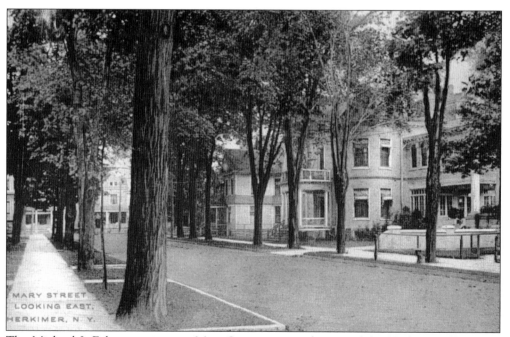

The Michael J. Foley mansion, on Mary Street, is now the site of the Herkimer Elks' Club. Foley was one of the founders of the Standard Furniture Company in 1886.

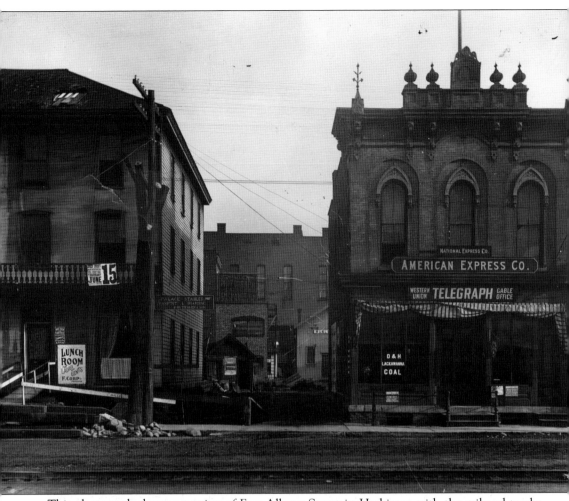

This photograph shows a portion of East Albany Street in Herkimer, with the railroad tracks visible in the foreground. The building on the left is part of the Nelson House, which extended to the corner of Main Street. The next building is the Telegraph and Express Office (later the Carleton Restaurant). Visible in the background is the opera house, facing Main Street. A sign indicates the Zintsmaster photographic studio, with its entrance on Main Street.

Six

PROVIDING FOR THE
COMMON DEFENSE

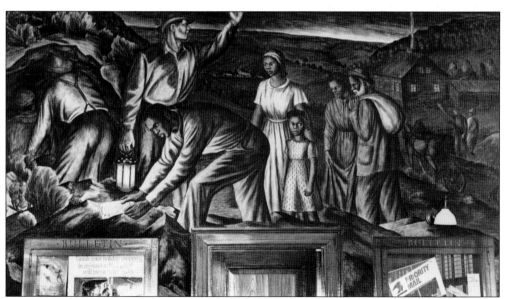

Some valley town residents aided runaway slaves by providing stations on the Underground Railroad. This mural by James Michael Newell on the post office walls in Dolgeville depicts activity at Zenas Brockett's Liberty House, two miles west of Dolgeville. The runaways are entering a cave, where they will rest during the daylight hours. One is studying an advertisement offering a reward for runaway slaves.

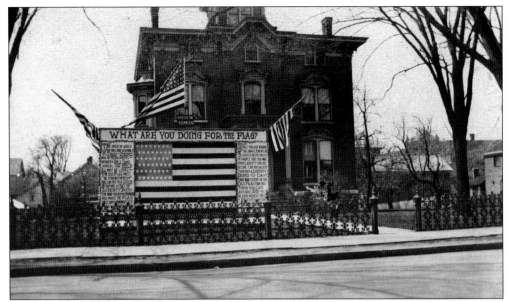

In front of the Herkimer Free Library was a barometer to measure the number of bonds sold in 1918. Designed by Paul Quackenbush, the flag was made of many hundreds of wooden blocks strung on horizontal steel rods. As bonds were sold, the appropriate number of blocks was added until the flag was completed. The blocks were made by the Standard Furniture Company.

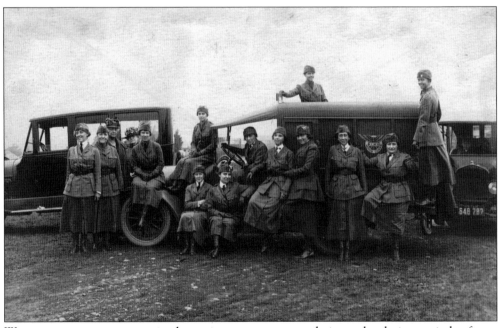

Women were eager to serve in the various ways open to their gender during periods of war. This group of women is serving in the National League for Women's Service, organized during World War I.

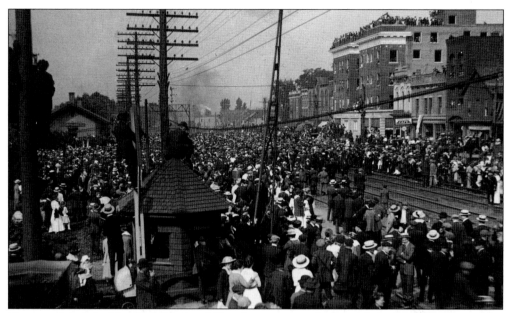

Company M of the New York National Guard was composed of men from the valley towns. This photograph shows the huge crowd gathered to wave them off on a troop train. Note the spectators on the rooftops. The men were trained in South Carolina and joined the 107th U.S. Infantry.

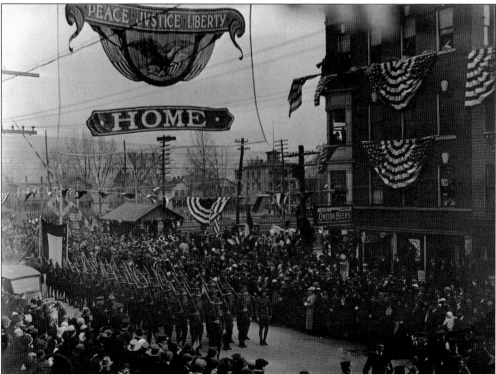

A gala homecoming for the men of Company M was held in April 1919. They left the train in Herkimer and paraded down Main Street to the courthouse, where other veterans joined them for a ceremony. The Company M Service Flag had 165 stars. Twenty-six of them were gold.

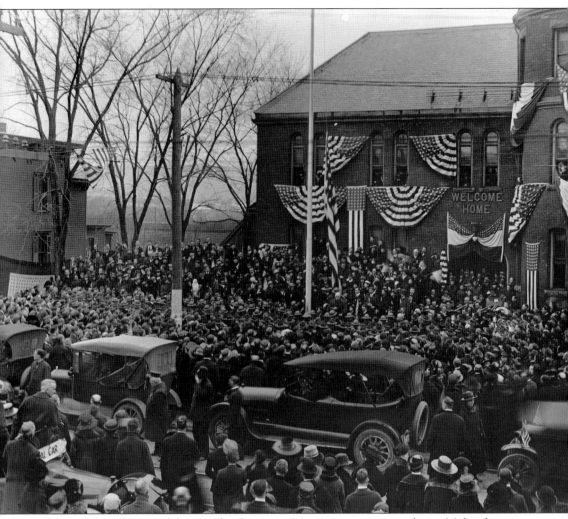

The welcome home celebration for Company M was just as spectacular in Mohawk as it was elsewhere. On reaching Mohawk, they marched up Main Street, where they were greeted in front of the armory. The Citizens Drum Corps provided music, and Congressman Homer Snyder gave a speech. Bleachers were set up for the relatives, and another was provided for the veterans, facing the podium. These men saw action in Belgium and France and were exposed to poison gas.

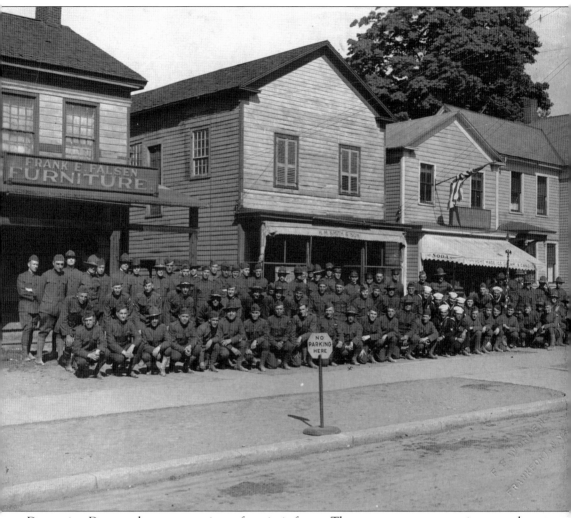

Decoration Day parades were occasions of patriotic fervor. These area men, representing several branches of the armed forces, are gathered for a parade c. 1920 in the village of Frankfort.

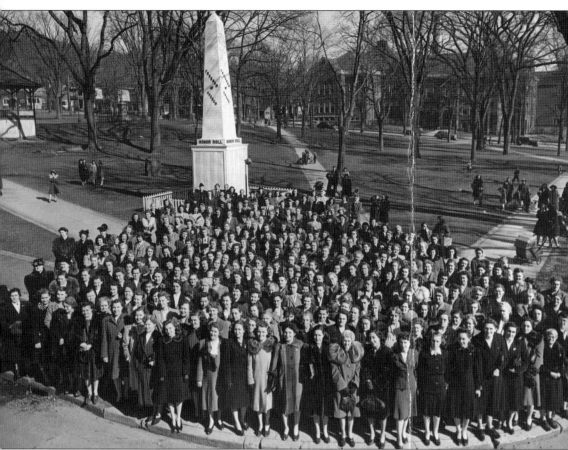

Proud wives and mothers of men in military services gathered in Eastern Park, Little Falls, in 1945. Alfred Eisenstaedt was the photographer, working for *Life* magazine, but the story was never published. These Herkimer County women did their part on the home front by participating in the Red Cross, economizing with rationing, working outside the home, and praying for the safe return of their men.

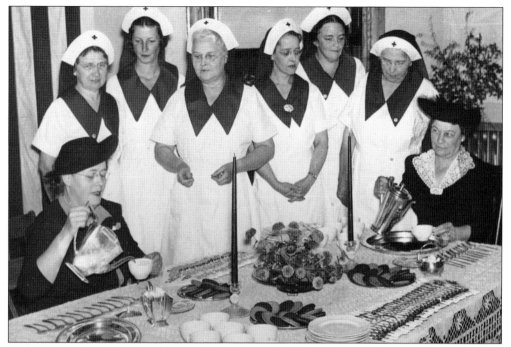

The Herkimer American Red Cross was organized in 1917 at a meeting called by Mayor A.F. Ertman. Three months later, there were more than 2,000 members from many local communities. This picture shows a group working on relief to World War II refugees in 1941. From left to right are Helen R. Morgan, Elsie Barns, ? Strickland, Lela M. Manion, Claire S. Kidd, Margaret A. Peck, Reba Helligas, and Eva Copeland.

These smiling women were the Ration Board of Herkimer County. Rationing began in May 1941 for rubber and oil. By 1942, all citizens were required to register for ration books. As the war effort increased, more products were rationed.

Steuben Hill in Herkimer was a good spot for civilian observers. Five hundred plane spotters manned 12 observation posts in Herkimer County. Two-hour shifts at the Steuben Hill post were manned by members of the Herkimer American Legion and by civilian aides. Rev. Gordon Kidd was the chief observer. In April 1942, a five-day test vigil was held.

Seven

THE PURSUIT
OF HAPPINESS

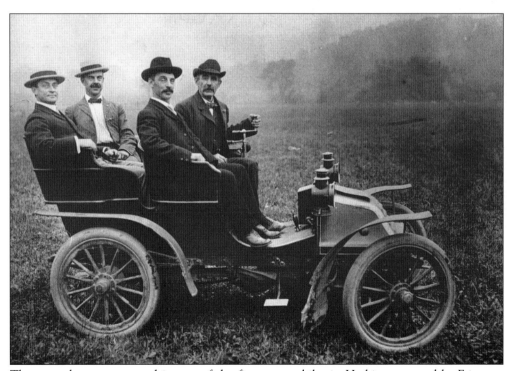

These gentlemen are seated in one of the first automobiles in Herkimer, owned by Frieman. Posing at the Herkimer County Fairgrounds on Mohawk Street are, from left to right, Alvah Zoller, Frank Rasbach, Irving Rasbach, and driver Peter Eysaman.

Ruth Porter Short took lessons at Grayce Chester Ingersoll's Studio of the Dance in Mohawk during the late 1920s. Ingersoll held classes in dancing and etiquette throughout the valley until 1947. Ruth, daughter of George and Mary Porter of Herkimer, remembers her as very civic-minded and generous. Students were admitted even if they lacked the means to pay for lessons.

When the postcard craze hit the valley, Ellen H. Clapsaddle, from the neighboring town of Columbia, created cards of beauty and good cheer. An example of her work is this Christmas card, with her typical happy children. She designed more than 2,500 postcards and made the Santa Claus image into the jolly fellow of today.

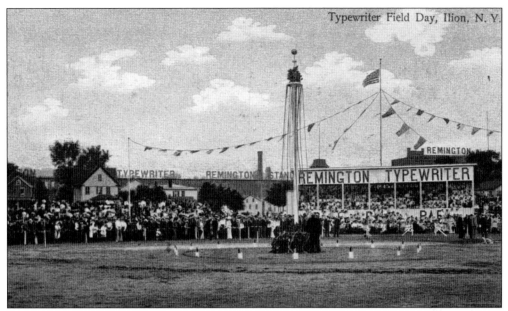

Company picnics and field days were common recreations for factory workers. These Remington Typewriter workers are enjoying a day on a recreation field in Ilion.

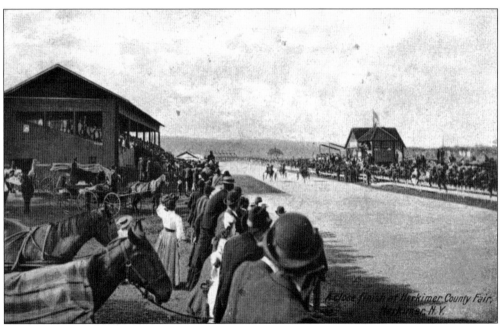

The Herkimer County Fair was held in Herkimer on land now part of the New York State Thruway interchange. After World War I, Frank T. Carroll purchased the grounds and converted them into Carroll Park. After the "fairless" years, Frankfort held fairs that developed into the county fairs of today. In 1957, the current fair site in Frankfort was purchased for the annual county fair, held in August.

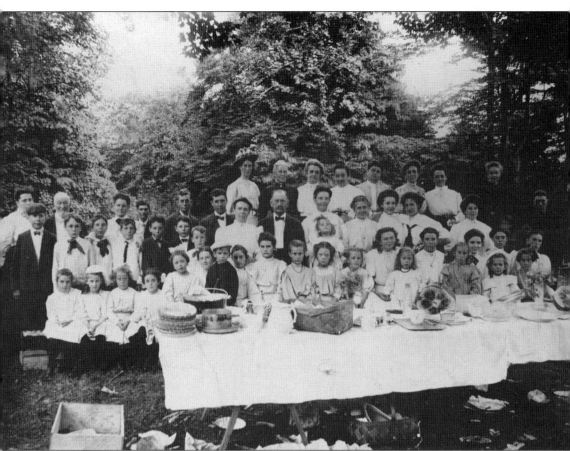

Enjoying a picnic are the Sunday school children and their leaders of the Yellow Church in the town of Manheim c. 1905. Manheim's earliest settlers in the Remensneider's Bush area, north of Little Falls, built a log church in 1733. It was burned by Tories and Native Americans in 1780. The fourth church on the site was built in 1882, a Reformed and Lutheran Union church. The last two churches were yellow, and the 1882 Yellow Church was razed in the late 1960s. An active association cares for the Yellow Church Cemetery, resting place of many Revolutionary soldiers.

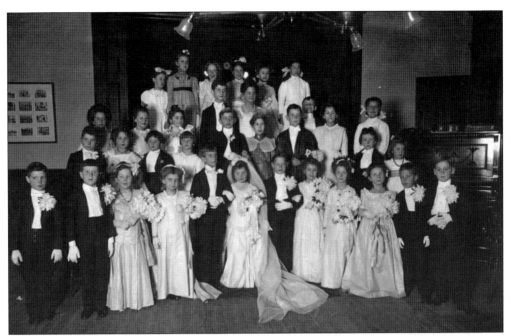

This Tom Thumb wedding was held at the Herkimer Reformed Church *c.* 1910. What seems to be a curious form of entertainment, these miniature weddings were once quite popular.

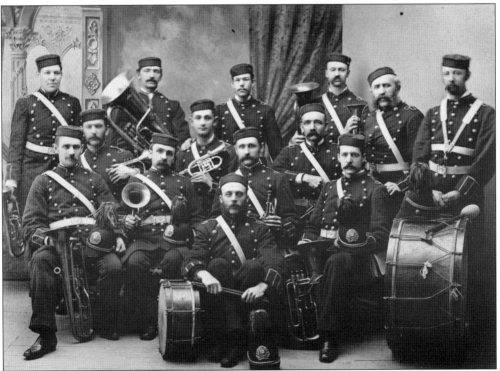

Many of the larger industries had their own bands that would play in parades, at picnics, and other festivities. This group is the Gates Match Factory Band from Frankfort. Note the elegant hats displayed by the men in the front row.

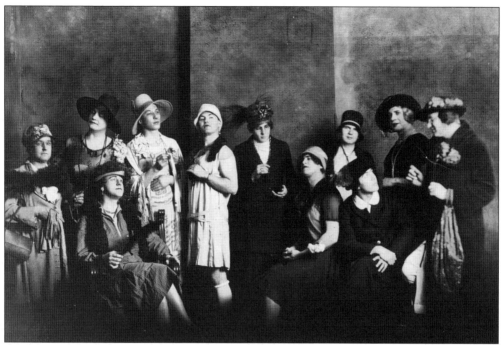

The lovely "ladies" are members of the Bachelor Club of Herkimer in their 1920s presentation of a "womanless wedding."

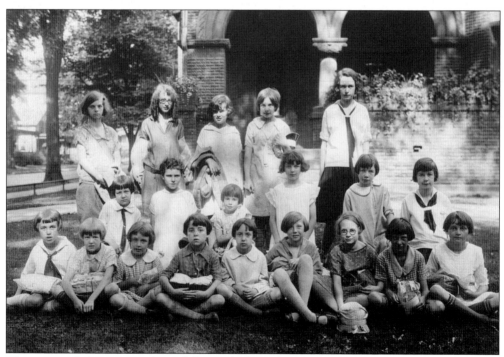

These young ladies are members of the newly formed Girls' Study Club of the Ilion Free Public Library. The girls pose in front of the library before starting a hike.

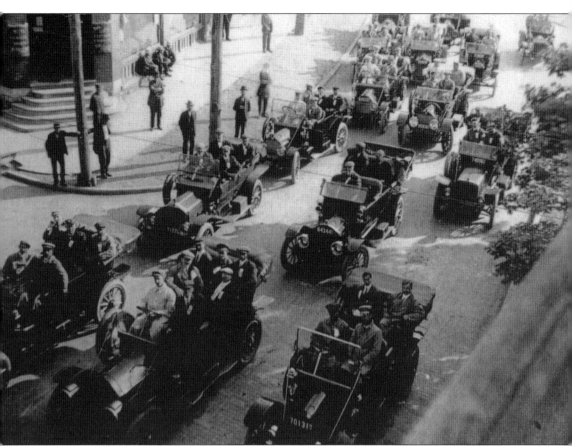

Dolgeville's South Main Street is the scene for this c. 1910 picture. They look like they are going somewhere, but the wheels headed in different directions indicate they are standing still. The auto club of about 15 Studebaker cars is parked in front of Morris Gennis' Dry Goods store. Thanks to the fine memory of Harold Smith of Dolgeville, we know that Lucy Bidgood is the lady on the extreme left. D. Rudes of Dolgeville is one of the drivers. The cars are all right-hand drives and two-seaters, except for the car in the center foreground with three seats. (Courtesy Dolgeville-Manheim Historical Society.)

In the 1800s, almost every community had an opera house. Herkimer's was on North Main Street, on the third floor. It could seat 1,200 people, with 300 more in the balcony. A café and billiard parlor occupied the same block.

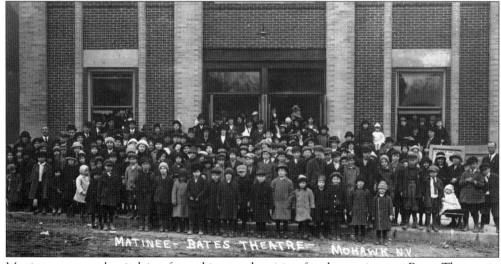

Movies were popular, judging from this crowd waiting for the matinee at Bates Theater in Mohawk. This theater was at the intersection of North Otsego and West Main Streets. It burned in the 1960s, and the Village Market now occupies that corner.

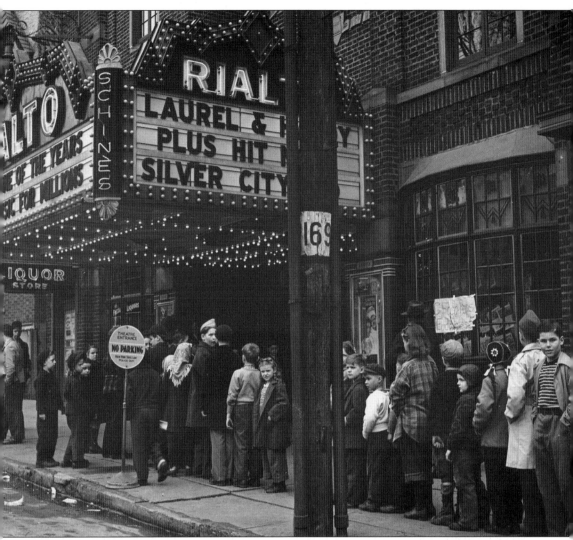

The Rialto Theater, on North Ann Street in Little Falls, is shown in a 1945 photograph taken by Alfred Eisenstaedt. The usual matinee line is waiting for entrance to the double feature. The first movie in Little Falls was shown in 1897. At first, opera houses were used for film audiences. In 1922, the Gateway Theater was built on North Ann Street and was later sold to the Schine Corporation. Schine changed the name to Rialto in 1925. The first sound pictures were shown in 1929 and marked the end of the organ accompaniment. In the 1940s, a child with a quarter could purchase a ticket and buy refreshments for a long afternoon of excitement.

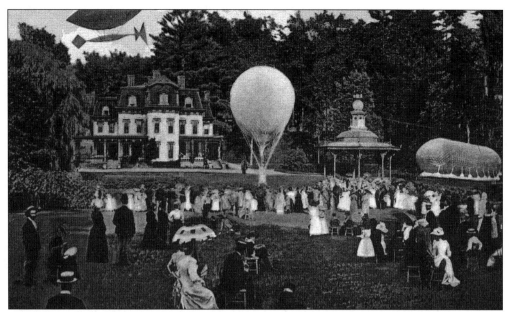

The famous Balloon Farm in Frankfort was formerly the mansion of Frank Gates of the Gates Match Factory. Gates sold the property to Charles and Mary Myers, otherwise known as Carl and Carlotta, hot-air balloonists.

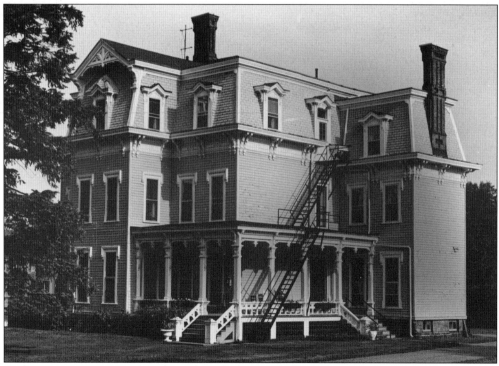

Carl Myers experimented with and made hot-air balloons in Frankfort. The half-inflated balloons on the lawn where the fabric was processed looked like large mushrooms, hence the name Balloon Farm. Carlotta, the Lady Aeronaut, appeared at fairs from 1880 to 1891, always drawing huge audiences.

The village of Herkimer celebrated its centennial in 1907 with many events and several parades. There was a celebration in Myers Park at the unveiling of Gen. Nicholas Herkimer's statue, and the bronze tablet marking the site of Fort Dayton was unveiled at the county clerk's office. The carriage formerly belonging to the Smith family was nearly a century old and owned by Ralph and Robert Earl. It was displayed in one of the parades, being drawn by a modern car. One of the parades was said to have featured 100 cars, the largest gathering of automobiles ever seen in central New York.

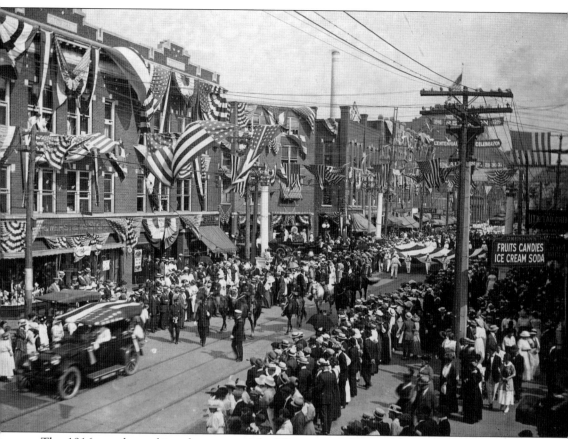

The 1916 parade marking the centennial of Remington Arms in Ilion makes its way down Main Street between bunting-adorned buildings. Note the large flag being carried and the flags waving—a picture of a patriotic America before involvement in World War I.

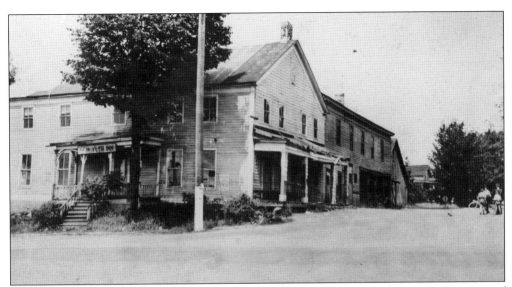

The Schuyler Inn (1811–1936) was a welcome sight to stagecoach drivers and the scene of many cotillion parties and dances. The dance hall was added *c.* 1850 as an annex. A store was conducted in the front of the building facing the Utica-Frankfort Road (Route 5) at the junction of Newport Road. (Courtesy Betty Currier.)

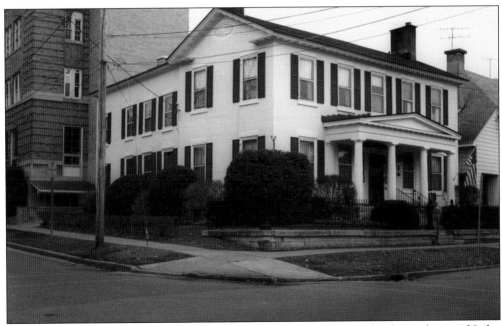

The Woman's Christian Association (WCA) in Little Falls occupies the former home of Judge Nathaniel Benton on Garden Street. The 1827 home in this photograph was donated to the WCA by Daniel Burrell and Elizabeth Burrell in memory of their sister Anne Louise Burrell. Many interesting programs and meetings are held here by local groups. (Courtesy George Dieffenbacher.)

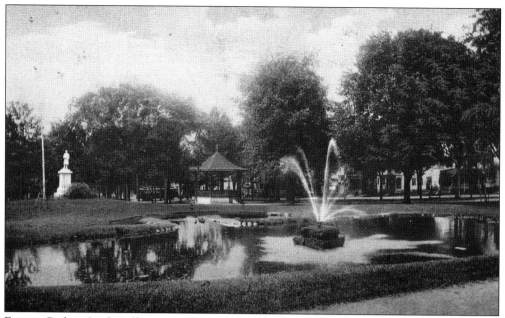

Eastern Park in Little Falls was a gift from John Ward between 1833 and 1839.

Little Falls' Western Park was the gift of six Albany residents *c.* 1832. Frequent band concerts were enjoyed by city residents.

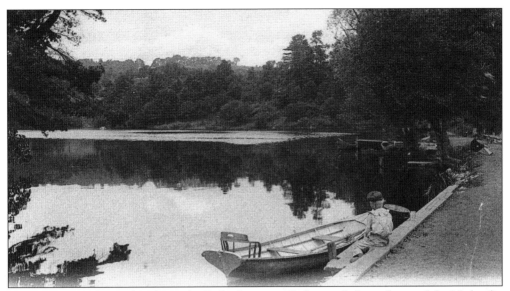

Mirror Lake was located at the end of Lake Street in Herkimer. It formed part of the Hydraulic Canal system and was developed into a recreational park by Frank Gray. In its heyday, 400 to 500 people would visit on Sundays. Two trolley cars bearing visitors would come from Utica. Ice was cut for storage in the winter.

Brookwood Park in Herkimer was abandoned in the 1970s. In 1982, members of the Kiwanis worked on the entranceway. The Brookwood Park Revitalization Committee was formed in 1992.

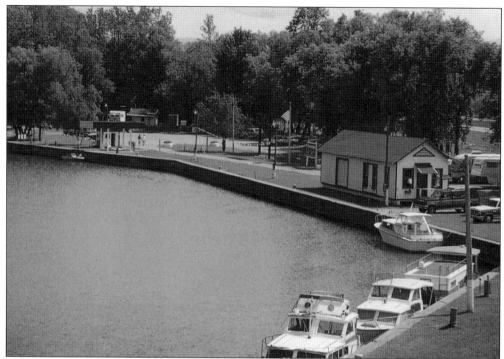

The Erie Canal offers great recreational potential. The Ilion Marina was built in 1961, the first canal marina in Herkimer County. Boats of all kinds travel the canal during the summer months, and valley communities are planning to use the advantages brought by increasing tourism.

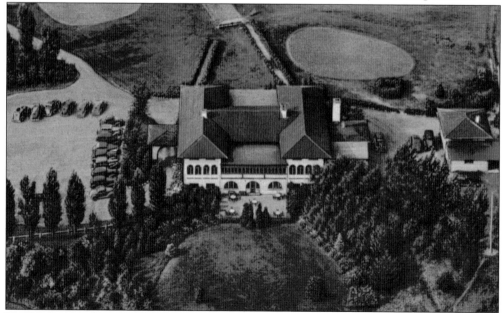

The Mohawk Valley Country Club on Route 5 began in 1907 as a nine-hole course called the Little Falls Country Club. The trolley car line brought visitors before the automobile became commonplace. The club burned in 1950 and was refurbished in 1951. This is the home course of Wayne Levi and one of the country's oldest golf courses.

Eight

PROMOTING THE GENERAL WELFARE

Before centralized school systems, every hamlet had a schoolhouse. Pictured here is the Shells Bush School (on the north side of Shells Bush Road), in use until 1913. The Rasbach residence is visible in the background. Students walked to school, and the school year was divided into terms that allowed children to remain at home during the busiest agricultural months.

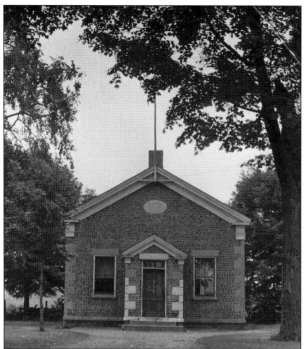

The East Schuyler Stone Schoolhouse was built *c.* 1849 by Nelson Thayer, who used cobblestones in its construction. The American Legion took over this schoolhouse in 1953, when Frankfort and Schuyler joined school districts. Later, the Schuyler Fire Department obtained the building, which is now the East Schuyler substation. (Courtesy Betty Currier).

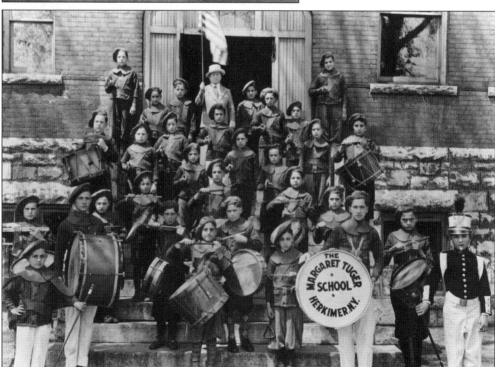

Margaret E. Tuger (back row, with flag), principal for 48 years in Herkimer, inspired children with her example of patriotism and civic responsibility. She nurtured and encouraged students of foreign extraction, welcoming them to the community. Tuger was famous for her tailored suits, white blouses, and her love of parades.

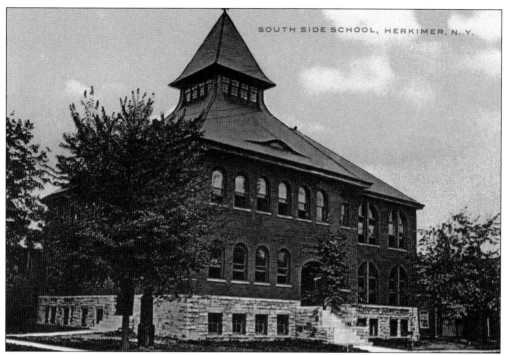

The South Side School—built in 1888 on South Main Street in Herkimer—was where Margaret Tuger began her career as teaching principal in 1891 with 200 mostly English-speaking students. A few years later, almost 1,000 students (many non-English speaking) were in attendance. This school was later razed. A new school was built in 1932 and was named the Margaret E. Tuger School.

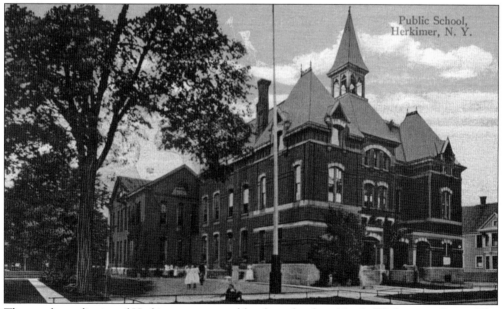

The northern district of Herkimer was served by this school on North Washington Street. The original brick structure of 1878 was replaced by the North School in 1923. It was renamed the Loraine W. Bills Elementary School in 1956 in honor of a longtime high school superintendent.

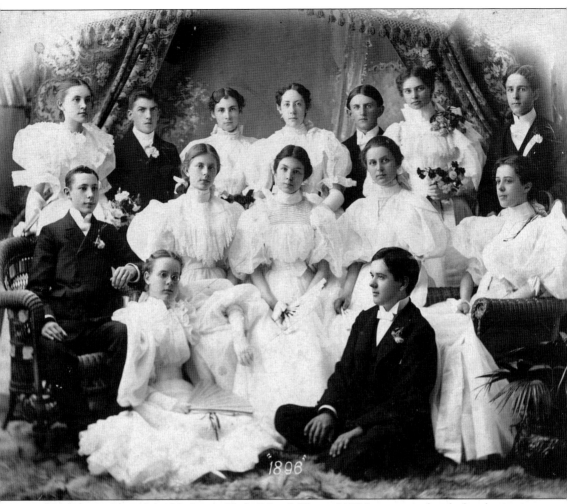

The 14 members of the Herkimer High School Class of 1896 pose together before beginning life in the outer world. They are, from left to right, as follows: (front row) Mary Snyder and William Bedell; (middle row) Walter Giersback, Mae Baker, Nellie Henderson, Gwendoline Gray, and Rose Wood; (back row) Alice Fay, Harry Fagan, Bertha Wright, Nellie Davis, Harold MacIntrye, Mabel Duddelston, and Clinton W. Metzger. These students attended high school in the old North School. In 1914, the new high school opened on the corner of North Bellinger and West German Streets. In 1959, the latest high school was completed.

When the old Church Street School in Frankfort was torn down, a middle school was built on the site. The middle school building now serves as the village offices and police department.

The Mohawk High School of 1892 vintage had two entrances, the girls' door on the east and the boys' door on the west. This school was erected on the site of a former school. Mohawk centralized with several communities south of the river in 1937.

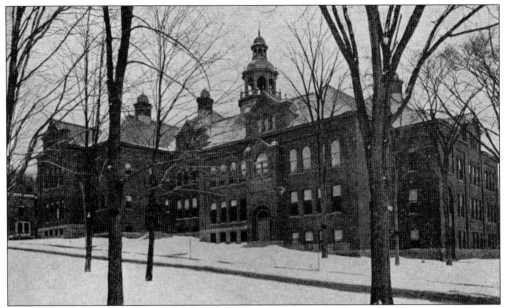

Little Falls Academy opened in 1845, with Nathaniel S. Benton as president, on the eastern side of Eastern Park. Local students and those from out of town attended classes. In 1868, a second building was built to the east and called Benton Hall. In 1900, a new grade school (Benton Hall) and high school were completed on the original site.

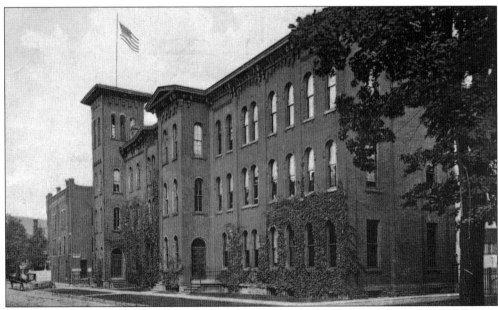

This school on Morgan Street in Ilion was built in 1865 in front of the old Stone Schoolhouse. The stone building was used for industrial arts and other classes, and a basement tunnel connected the two buildings. The schools were sold to the village in 1927. The municipal building now occupies this site.

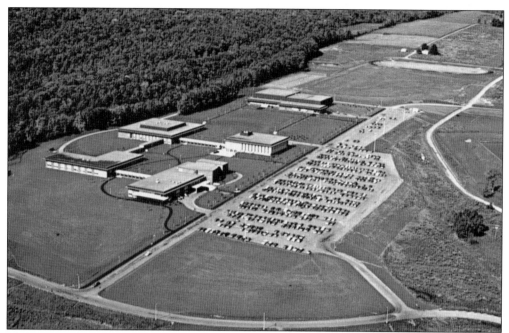

The Herkimer County Community College has expanded tremendously since this picture was taken in the 1970s. The idea of a community college came from the Dolgeville area. Edwin Vosberg's suggestion in 1962 spurred the formation of a committee headed by Richard Jorrey and, by 1967, the first classes were held in the UNIVAC plant in Ilion. The campus is now on a hilltop in west Herkimer.

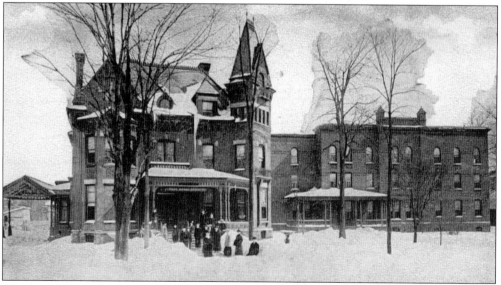

The Folts Mission Institute on North Washington Street in Herkimer was incorporated in 1893, organized under the auspices of the Methodist church. Elizabeth Snell Folts asked her husband, George Philo Folts, to donate the family home as a school for the education of missionaries. The school operated until 1928 under different administrations. In 1943, it was reopened as the Folts Home for the Aged. Continual expansion and addition of facilities has resulted in a modern residential healthcare facility.

The 1923 class of Folts Mission Institute received a theological education. For a time, the school was administered by the Methodist Women's Foreign Missionary Society and, later, by the Women's Home Missionary Society. The school acquired national support from the Methodist church in 1918. Graduates were sent to foreign missions in India, China, Japan, Mexico, and Africa. Some of the young women served in the United States, working in urban settlement houses, orphanages, and mission schools.

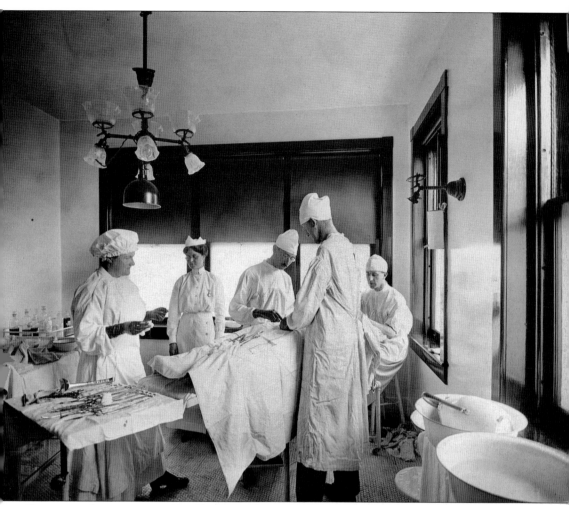

Doctors perform surgery in the Herkimer Emergency Hospital, on North Washington Street, c. 1912. From left to right are Lela Manion, Margaret (Perry) Ketchum, Dr. Howard C. Murray (operating), Dr. John E. Canfield (assisting), and Dr. Edward B. Manion (anaesthetist). When the need for a hospital was realized, Levi Lawton donated part of his property, and the cornerstone was laid in 1902. Nine beds were available, and general care was provided as well as emergency. The Stitchery Club was organized in 1911 by Herkimer women who sewed for local hospitals.

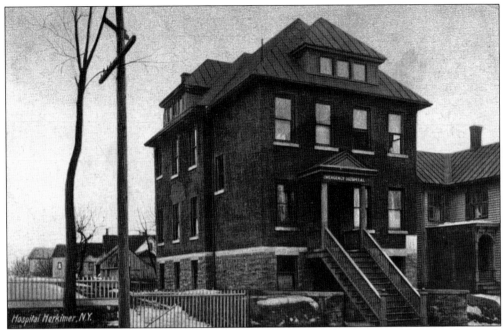

The Herkimer Emergency Hospital served until well after World War I. By 1925, a new hospital, Herkimer Memorial, was opened on Oak Hill. New wings increased the size to 72 beds, but mounting debt caused a transfer to the village of Herkimer. In 1983, the hospital closed and was taken over by Valley Health Services, which operates a long-term care facility.

The first Little Falls Hospital opened in 1893 on Ann Street due to the efforts of Helen C. Waite, Alice Bushnell, and a committee of women. In 1892, the hospital moved to Monroe Street. Another move was necessary in 1904, when property was purchased on Burwell Street. This picture shows this facility before the addition of the third story in 1908. A training school for nurses was maintained from 1896 to 1928.

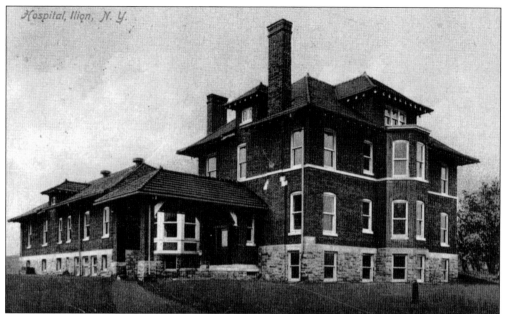

The Ilion Hospital was completed in 1909 due to the support of Dr. Jennie Richardson and Henry Harper Benedict's donation of funds. The Ilion's Women's Associate Board prepared linens for the hospital. New buildings were added. In 1964, the name was changed to the Mohawk Valley General Hospital. The Mohawk Valley Nursing Home was added in 1971 and is currently in operation. The hospital is closed.

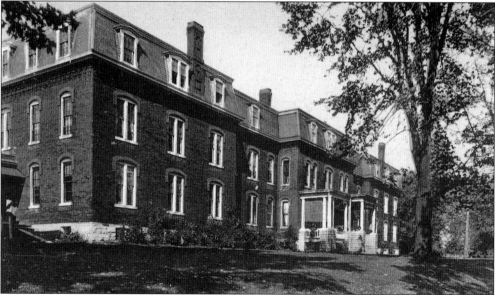

From 1857 to 1976, these buildings served as the Herkimer County Home and were a familiar landmark to Route 28 travelers from Herkimer to Middleville. County poor, sick, homeless, insane, and orphaned were housed in this complex as the state mandated such care over the years. In 1973, a new Herkimer County Home for the Aged was opened across the road. Today, the new facility is called Country Manor and provides a home for the elderly from all walks of life.

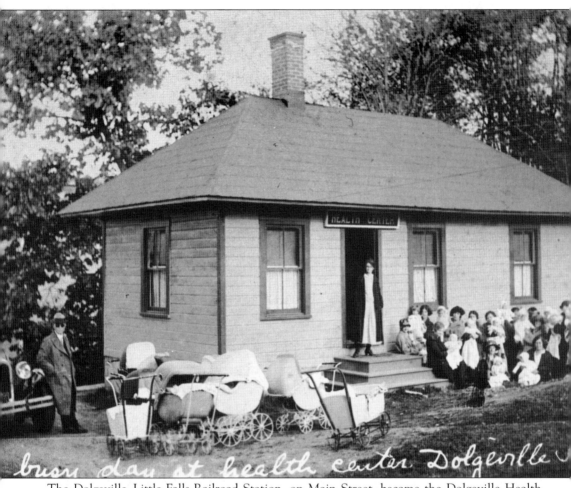

busy day at health center, Dolgeville

The Dolgeville–Little Falls Railroad Station, on Main Street, became the Dolgeville Health Center *c.* 1920. Nurse Anna B. Landon ran the clinic and organized the Little Mothers' League. She taught child care to the group's members.

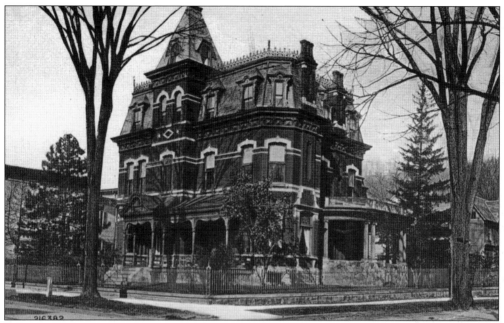

Judge Rollin H. Smith (1838–1911) left his home for the establishment of a library in Little Falls. The collection begun by the public school in 1895 was moved into the elegant home. From 1912 to 1930, the library was a combination school and city library. Then, a separate library was located in the high school. An addition to the public library was built in 1982.

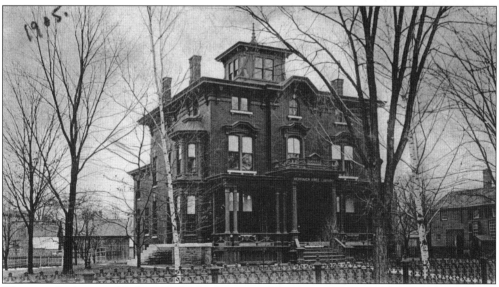

This was the home of Robert Earl (chief justice of the Court of Appeals) and his wife, Juliet Wilkinson Earl. The Regents granted a charter for the Herkimer Free Library in 1895. In 1896, the title deeds were presented to the library trustees. The Earls also gave 2,000 volumes, and 1,000 more were added by the Morris Mark family. In 1974, the village purchased the former Acme Market building. The library moved to new quarters in 1975, helped by the generosity of the Basloe family. The library is now known as the Frank J. Basloe Library.

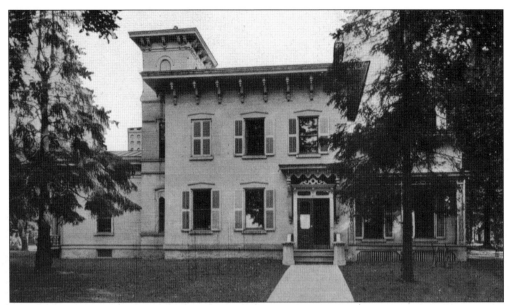

The Weller Library in Mohawk was made possible by a gift from Frederick V. Weller and his wife, Helen (Spencer) Weller. The building and park were deeded to the village in Helen Weller's will. The building was erected by Cornelius Dievendorf, and Weller purchased it in 1857. The library opened in 1914.

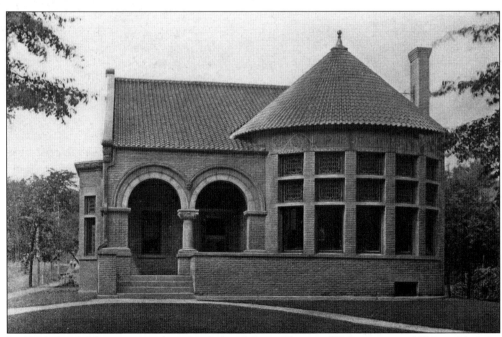

In 1884, Ilion's library was in the school. A gift from Clarence W. Seamans in 1893 enabled the village to build the Ilion Free Public Library. An addition was built in 1972.

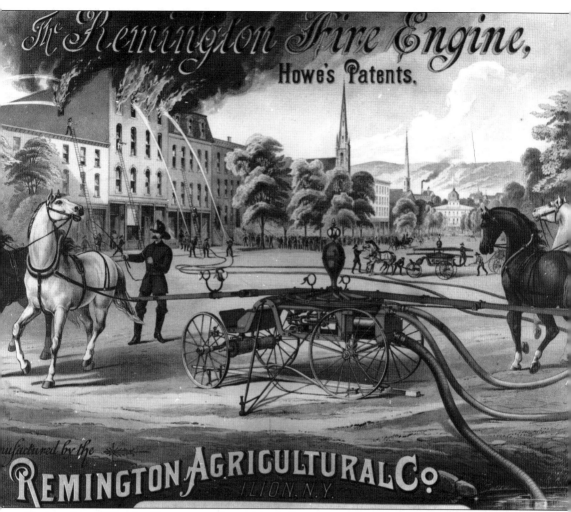

During the 1880s, the Remington Agricultural Company manufactured horse-powered fire engines. They featured three double acting pumps, 200 gallons per minute. While one man fastened the engine to the ground with iron braces, another man attached the hose. One or two spans of horses could be used, traveling in a circle. Advertisements for this engine pointed out its advantages: "It does not require the services of an engineer, fireman, mechanic, or other expert; there is no waiting for supply of fuel nor cost of same; no time lost in getting up steam; no danger from boiler explosion, no flues to burn out, rust, or blow up; no expensive repairs."

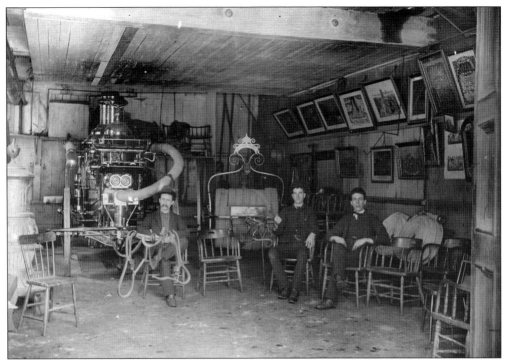

Ilion Hose Company No. 2 (formerly the Excelsior Hose Company and later the C.W. Carpenter Hose Company) formed part of Ilion's fire protection system. The fire companies were the center of many social events, such as balls, annual parades, and the county fire conventions. This photograph shows fire equipment c. 1883.

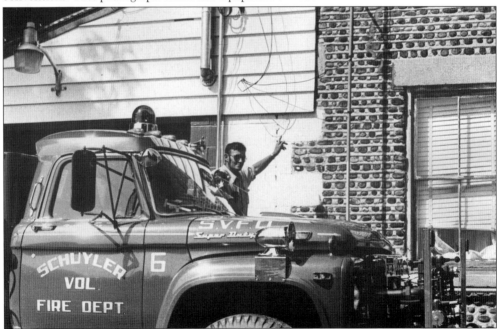

The Schuyler Volunteer Fire Department's fire pumper is manned by Robert Pashley (assistant fire chief) in 1982. Visible is the cobblestone schoolhouse that was converted to a firehouse.

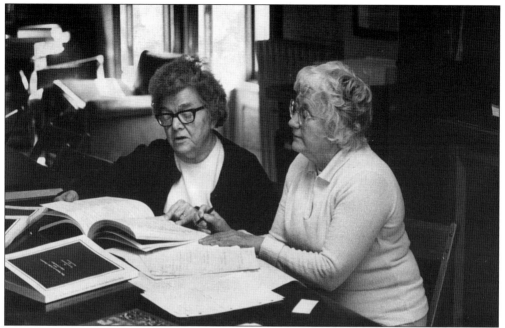

The Herkimer County Historical Society has a long history of volunteerism. Hazel Patrick, on the left, and Marion Kofmehl are shown editing a book published by the society. Hazel Patrick wrote several genealogy books and searched old newspapers for obituaries and marriages. Marion Kofmehl also authored family history books.

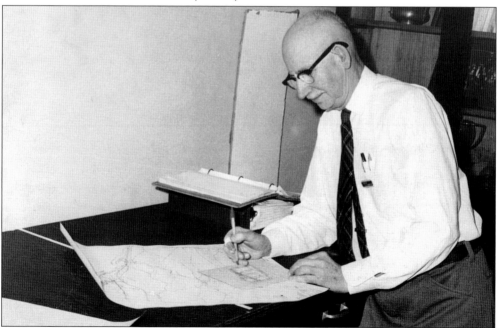

George Hildebrant is shown consulting a map at the Herkimer County Historical Society in 1978. He visited every known cemetery in Herkimer County and recorded the information on the grave markers up to 1930. His work on indexing historical volumes has saved researchers countless hours.

These faces from the past will close our visit to Herkimer County's valley towns. They are unidentified but representative of the many who had their portraits done at the Zintsmaster photographic studio in Herkimer. These photographs were donated to the Herkimer County Historical Society's collection by John Graves.

A.P. Zintsmaster and his son Max recorded Herkimer's people and places for many years. Albert P. Zintsmaster conducted a studio beginning in 1893. Max took over the business in 1927. The studio was located near the Liberty Theater site at 122 North Main Street and, at one time, on Park Avenue. In 1945, the business became the Robel Studio, owned by Donald C. Robertson and Lloyd G. Elston.